IMAGES
of America

LAKEWOOD

To my daughter, Thealexa

IMAGES
of America

LAKEWOOD

Thea Gallo Becker

ARCADIA
PUBLISHING

Published by Arcadia Publishing
Charleston, South Carolina

Printed in the United States of America

Library of Congress Catalog Card Number: 2003104864

For all general information contact Arcadia Publishing at:
Telephone 843-853-2070
Fax 843-853-0044
E-mail sales@arcadiapublishing.com
For customer service and orders:
Toll-Free 1-888-313-2665

Visit us on the Internet at www.arcadiapublishing.com

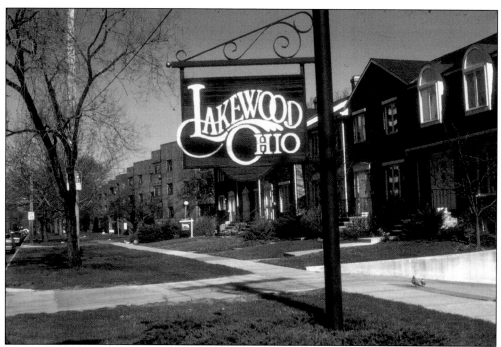

WELCOME TO LAKEWOOD, OHIO. This sign stands at the intersection of Lake Avenue and West 117th Street facing Lakewood's eastern border with Cleveland. The image is looking down the north side of Lake Avenue at the townhouses and apartments.

CONTENTS

ACKNOWLEDGMENTS

The photographs in this book were obtained primarily from two sources—The Lakewood Historical Society and the Cleveland State University Library's Special Collections area. First, I would like to express my sincerest thanks to Mazie Adams, Executive Director of the Lakewood Historical Society, for allowing me to use the collection in selecting images for this book, many of which are being published for the first time. The CSU Special Collections is an outstanding repository of photographs, not only of Lakewood, but also of the Greater Cleveland area. Many of these photographs can be found on their Cleveland Memory website: http://web. ulib.csuohio.edu/SpecColl/. The following institutions also provided photographs, Cuyahoga County Archives, St. Augustine Academy, and St. James Parish. Finally, I wish to thank Mr. Jim Spangler and Mr. Bruce Young for providing photographs from their private collections.

In doing my research I found the following books to be most helpful: Margaret Manor Butler's *The Lakewood Story* (1949); E. George Lindstrom's *Story of Lakewood* (1936); and The Fire and Police Pension Fund's *History of the City of Lakewood* (1915). Finally, *The Cleveland Press Collection* clipping and microfilm files at CSU provided a wealth of information not usually found in other printed sources.

Author's Note: Images from The Lakewood Historical Society are cited as "(LHS)."
Images from Cleveland State University Library's Special Collections are cited as "(CSU)."
All other images are identified by the individual donor.

INTRODUCTION

The City of Lakewood is an inner-ring suburb located on the western border of Cleveland in northeast Ohio. It occupies 5.6 square miles on the southern shore of Lake Erie. The name Lakewood came from its natural setting along the lake. It was originally designated as Township 7, Range 14 of Rockport Township of the Western Reserve. Included in Rockport Township was the suburb of Rocky River, located to the west of Lakewood. The Hamlet of Lakewood was founded on August 31, 1889, when the population reached 400. It became the Village of Lakewood on May 4, 1903, with a population of over 3,300. When Lakewood was finally incorporated as a city on February 17, 1911, the population had surpassed 15,000, and a building-boom was underway.

Lakewood's development has been historically linked with that of Cleveland and Rocky River. Many of the early settlers who came to the Western Reserve and Cleveland traveled no further west since the area beyond seemed uninhabitable and hostile. Those that did venture westward along the old Indian path that was to become Detroit Avenue, such as James Nicholson, the first permanent settler in what would become Lakewood, found the Rockport area suitable for development. Along with other early pioneers like Dr. Jared P. Kirtland and Mars Wagar, the area along Detroit Avenue was gradually settled with homes made of clay bricks and stone, two of Lakewood's natural resources. From the 1830s through the 1850s as more settlers arrived the area gained distinction for its rich soil, and soon fruit growing emerged along with brick making as its earliest leading industries.

As the fruit farms, orchards, and vineyards grew so, too, did the need to transport them easily to Cleveland. The old Indian path was covered by wooden planks creating a plank road for easier travel. Taverns sprang up alongside Detroit Avenue offering weary travelers a place to rest and refresh. To pay for road improvements Detroit Avenue became a toll road and would not be free until 1901. Travelers began using the road for more than commerce as resorts opened on both sides of the Rocky River Valley. For those who wished to travel faster a small Dummy or Dinky Railroad was built to take vacationers from Cleveland to these lakeside resorts.

The area around the intersection of Detroit Avenue and Warren Road gradually became the center of town and gave rise to a thriving commercial district. It was on Warren Road that Lucius Dean, the area's first Postmaster, ran a small general store where he would collect residents' mail for distribution. In 1871 voters approved creating a separate school district east of Rocky River called East Rockport. One of the first schools was opened on Warren Road.

Lakewood would build an outstanding school district of 14 public schools enhanced by an outstanding library system providing both community and educational needs.

By the 1870's families with names like Andrews, Hall, and Hird had purchased large tracts of farmland that extended north from Detroit Avenue to Lake Erie and had built large homes along Detroit Avenue. Realizing the richness of the soil to support sprawling vineyards and orchards these families built their farms into prosperous enterprises, which added to their personal wealth and contributed to Lakewood's reputation as a major fruit grower and supplier.

The discovery of natural gas deposits in Rockport stimulated Lakewood's transition from a farming community to one of business and industry. Wells were drilled as early as 1883, with one yielding almost 22,000 cubic feet of natural gas daily. Additional natural gas reserves were discovered in 1911, but were exhausted within a few years. The construction of a municipal light plant in 1896, the opening of a streetcar line in 1903, and the development of the automobile facilitated Lakewood's growth.

The opening of the Detroit-Superior High Level Bridge in 1917 made travel from downtown Cleveland to the west side easier and sparked a real estate boom in Lakewood. Community boosters advertised Lakewood as the *City of Beautiful Homes* because of the magnificent private estates built along the lakefront and especially the Clifton Park area in western Lakewood. By 1920, the City's population had surpassed 40,000, and it continued to attract more residents.

The post-World War I era saw a rise in multi-family and apartment dwellings as the City tried to keep up with the housing demands of returning veterans. The growth of neighborhoods brought with it an increase in the number of small businesses, many of them family-owned, along Detroit Avenue and Madison Avenue. Soon commercial blocks with ground-level store fronts and second-floor apartments lined the streets. Major retailers like The Bailey Company opened in Lakewood. By 1930 Lakewood reached a population peak of over 70,000, a figure the City would see steadily decline.

By the end of the 1940s Lakewood had developed nearly all available land and had no place to build—except up. During the 1950s and 1960s Lakewood experienced a marked increase in the construction of multi-family units. The most dramatic impact occurred along the Gold Coast area in northeast Lakewood where the landscape assumed a new look as developers demolished older and once beautiful lakefront estates to make room for new lavish high-rise apartment buildings, condominiums, and townhouses.

With a present population of just over 56,500 residents Lakewood continues to build and refine itself into a community eagerly anticipating the future as much as the early pioneers who contributed to Lakewood's diverse history.

Thea Gallo Becker

One

FARMING, BUSINESS, AND INDUSTRY

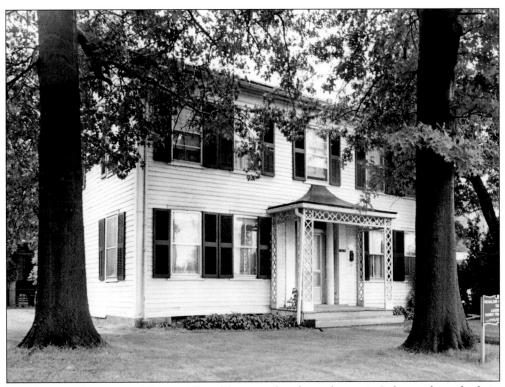

THE JAMES NICHOLSON HOUSE. The oldest wooden frame house in Lakewood was built in 1835 by James Nicholson, the area's first permanent settler. Located at 13335 Detroit Avenue, this simple two-story white colonial is typical of the New England architectural style to which Nicholson was accustomed before he came to Rockport Township from Massachusetts in 1818. In 1979 the Nicholson house was placed on the National Register of Historic Places. (LHS.)

THE MAILE BRICKYARD. This 1910 photograph shows the brickyard of Christopher Maile, son of William R. Maile, Lakewood's earliest and most successful brickmaker and Hamlet trustee. Christopher Maile opened this brickyard on Hilliard Boulevard and Warren Road. The richness of the soil made brickmaking one of the earliest industries in Lakewood. Early settlers turned away from log cabins and used the sturdier brick or sandstone for building homes. (LHS.)

THE FIRST BRICK HOUSE IN LAKEWOOD. Price French, an early settler who came to Rockport Township in 1828, built the first brick house in Lakewood on the southwest corner of Detroit and Wyandotte Avenue. The two-story mustard-colored home used bricks made from clay, an abundant natural resource in Lakewood. The home featured an open front porch. Like many other historic homes on Detroit Avenue, it was razed for commercial use. (LHS.)

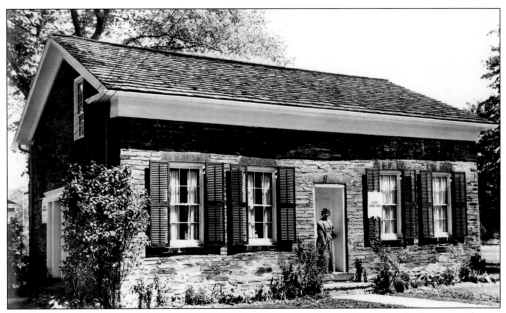

THE HONAM-HOTCHKISS HOUSE. In 1838 John Honam, a Scottish weaver, built a stone house on the northwest corner of Detroit and St. Charles Avenues. He used Berea sandstone dug from a nearby quarry. His daughter Isabelle resided in it with her husband, Orville Hotchkiss, until 1870. Margaret Manor Butler, standing in the doorway, curator of the Lakewood Historical Society, led a campaign to save Lakewood's oldest stone house. (LHS.)

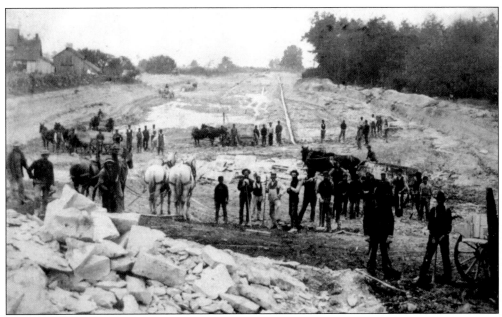

CONSTRUCTION OF BELLE AVENUE. Many of Lakewood's early settlers purchased large tracts of land extending from Detroit Avenue down to Lake Erie. As land values appreciated from an original purchase price of about $10/acre to as much as $2,000/acre, landholders like Nicholson and Honam sold their interests. In this photograph workers are cutting a new road, Belle Avenue, named for Isabelle Honam-Hotchkiss whose family had owned the land. (LHS.)

11

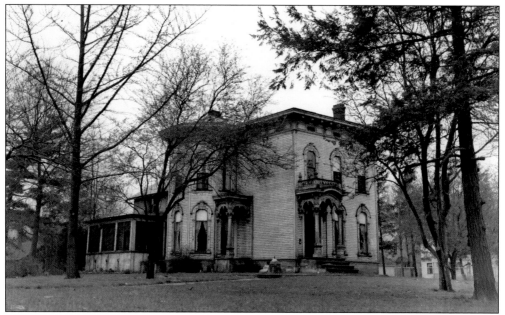

THE JOHN C. HALL HOUSE. John Hall, the youngest child of Joseph and Sarah Hall, built this home at 16913 Detroit Avenue in 1875. The Hall family, prosperous fruit farmers, owned large tracts of land along Detroit Avenue on which they built magnificent homes. This Victorian mansion featured ceiling-high windows, large rooms, and marble fireplaces. After it was razed the site was used for a park before becoming home of the YMCA/YWCA. (LHS.)

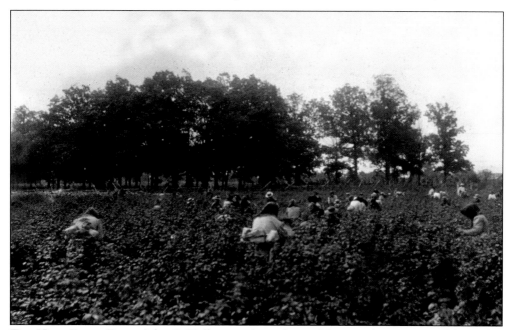

THE HALL FRUIT FARM. John C. Hall was perhaps the wealthiest and most successful member of the Hall family, building up one of the largest and most productive fruit farms in the area. Here is an open field on the Hall farm, which extended north from Detroit Avenue to Lake Erie. Workers are busily picking fruit with small straw baskets tied to their sides. (LHS.)

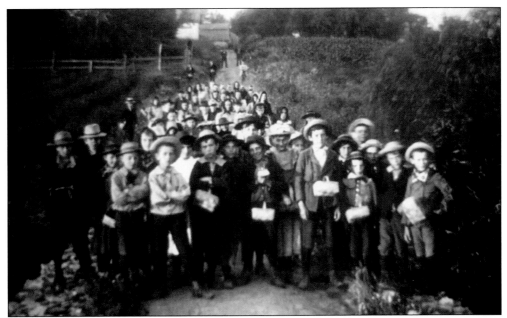

THE BERRY PICKERS. Early settlers discovered that Lakewood's rich soil was ideal for growing fruit. Soon fruit farming became a thriving business. Grapes, strawberries, blueberries, apples, peaches, and pears grew in abundance as Lakewood became a major supplier of produce for Cleveland. Growers owned large estates on which workers, including entire families, tended the orchards and vineyards. Here a group of hearty children are toting their fruit baskets to harvest the day's yield. (LHS.)

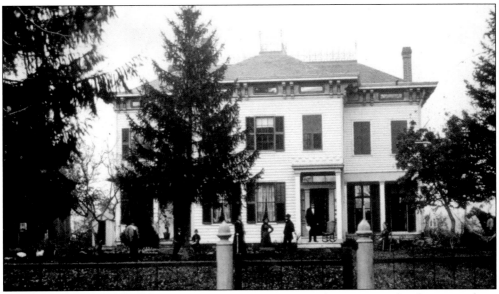

THE ANDREWS FAMILY HOME. One of the most prosperous fruit-growing families not only in Lakewood but all of Ohio was the Andrews family. They owned 80 acres of the richest land extending from Detroit Avenue north to Lake Erie between Andrews and Lakeland Avenues. In 1853 they built this elegant two-story Victorian home at 15316 Detroit Avenue. It was razed in 1948 for a shopping center plaza. (LHS.)

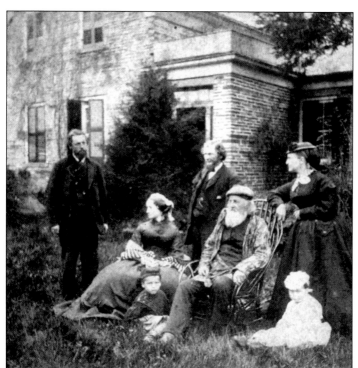

DR. JARED POTTER KIRTLAND. Famed naturalist and physician Dr. Kirtland, with his trademark white beard and a hat, sits surrounded by family on the grounds of his estate. In 1810 Dr. Kirtland came to Cleveland and shortly thereafter made his home in Rockport Township. One of the 19th century's leading naturalists, Dr. Kirtland created beautiful gardens and orchards on his estate where he discovered numerous different varieties of fruits. (LHS.)

THE KIRTLAND ESTATE. In 1839 Dr. Jared Kirtland built his first home on the southwest corner of Detroit Avenue and Bunts Road at 14013 Detroit. He remodeled and enlarged his home (originally built of stone) over time to include bay windows and open porches. The entire Kirtland estate, including gardens and orchards, comprised approximately 200 acres from Madison Avenue north to Lake Erie. It was razed for a supermarket. (CSU.)

ELIJAH AND THE ROCK OF AGES. Seated on the front steps of this rustic little shack is Elijah, who worked as a hand on the Kirtland estate for many years. Affectionately called the *Rock of Ages*, Elijah's home was located on the estate grounds in the area that is now the site of Lakewood High School. Looking closely one can almost read the address 13042 on the front of the house. (LHS.)

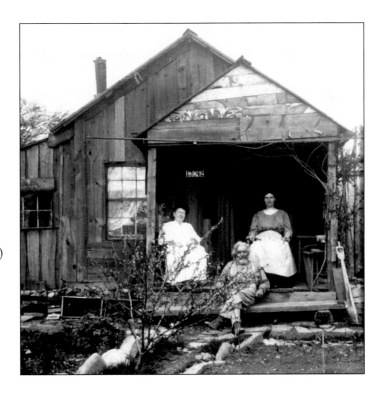

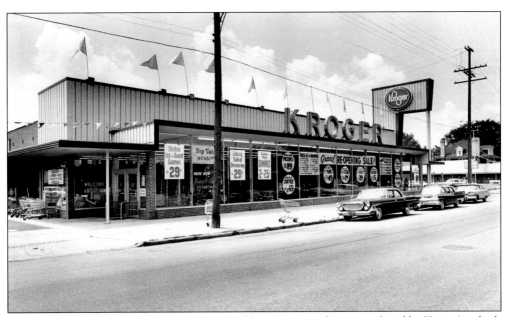

KROGER GROCERY STORE. When the Kirtland home was razed it was replaced by Kroger's, which later became a Rini-Rego supermarket and then a Giant Eagle supermarket. Many structures of historic significance built by Lakewood's earliest settlers were demolished for commercial use. In this 1963 photograph Kroger's advertises its "Grand Re-Opening Sale!" Among the specials: golden ripe bananas, 2 lbs. for 25¢ and Embassy salad dressing at 29¢ a quart. (CSU.)

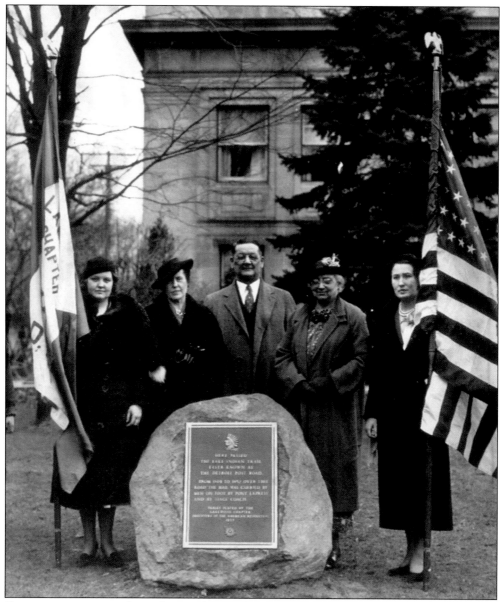

COMMEMORATING THE LAKE INDIAN TRAIL. Detroit Avenue, U.S. Route 6, was the road that brought the early settlers to Rockport Township. Today it is the main east-west road running through the center of Lakewood and its downtown business district. In April 1937 Mayor Amos I. Kauffman and members of the Lakewood Chapter of the Daughters of the American Revolution (left to right) Mrs. William Hawley, Mrs. McElden Lohr, Rowena Ingham, and Mrs. Charles Miller, presented a plaque commemorating the Lake Indian Trail that was mounted to a boulder set in front of the main library on Detroit Avenue. The inscription read: "Here Passed The Lake Indian Trail Later Known As The Detroit Post Road. From 1809 to 1852 over this Road the Mail was carried by Men on foot, by pony express And by stagecoach. Tablet placed by the Lakewood Chapter Daughters of the American Revolution 1937." The plaque and boulder are now gone, but the importance of Detroit Avenue in Lakewood's early history and commercial development remain. (LHS.)

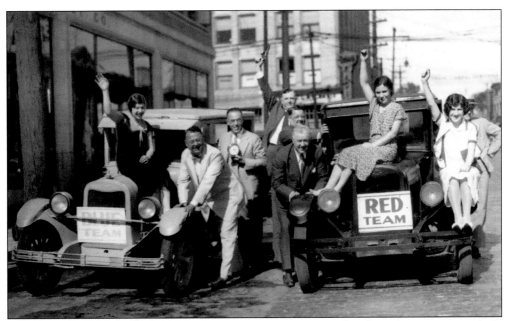

THE CHAMBER OF COMMERCE. Every municipality needs a chamber of commerce to help promote growth through business and industry, education, transportation, and government services. Lakewood's organization began in 1911. Posing as cheerleaders next to The Bailey Co. during a 1931 campaign drive are, from left to right, Anne Zagaros, R.C. Hyre, Brian Bowman, Dr. R.B. Crawford, Amos Kauffman (finance director), Mayor Edward Wiegand, Edythe Perlman, Alice Evans, and unidentified. (CSU.)

THE DETROIT-WARREN BUILDING. The five-story Detroit-Warren Building opened May 19, 1924 on the southwest corner of Detroit & Warren, the former site of the Jacob Tegardine residence, Lakewood's first city hall. Designed by the Lehman-Schmidt Company, it was the first building in Lakewood to provide elevator service. The ground floor featured Weinberger's, a drug store chain. It was added to the National Register of Historic Places in 1986. (LHS.)

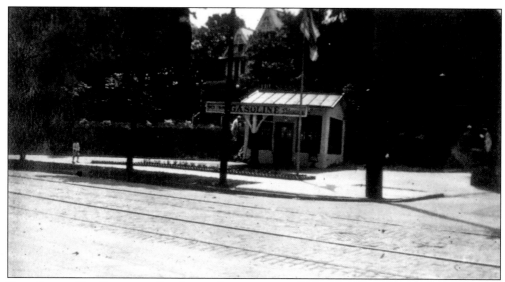

RED CROSS GAS STATION. On the southeast corner of Detroit and Warren stood this small, wooden-frame one-room gas station photographed in 1915. Across the top of the roof is a sign that reads "The Standard Oil Co." Above the front door is another sign reading "Gasoline." Behind the station is a large Victorian frame house built around 1888 by Francis Wagar, son of early settler Mars Wagar. (LHS.)

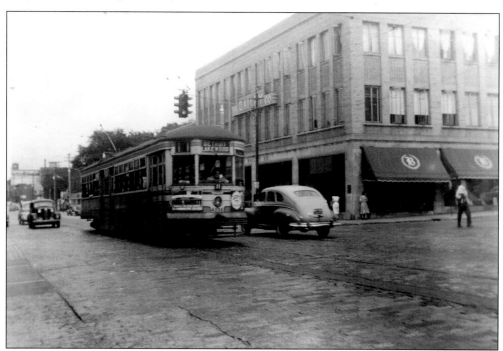

THE BAILEY COMPANY DEPARTMENT STORE. Bailey's, a major downtown Cleveland department store, opened its first suburban branch in 1930 in Lakewood. The southeast corner of Detroit and Warren was cleared when both the Red Cross Gas Station and the Francis Wagar home each were demolished. Bailey's in Lakewood was also the first suburban branch opened by any major American downtown department store. Bailey's stayed in business until 1965. (CSU.)

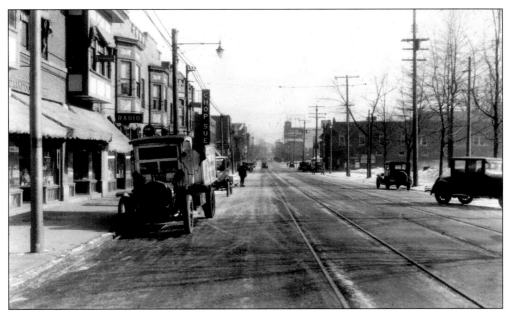

DETROIT AVENUE DURING THE 1920S. This 1926 photograph taken from the intersection of Detroit Avenue and Warren Road looking east highlights the commercial block on the north side of Detroit. Among the businesses are a radio shop, a drug store, and a Chinese restaurant. Streetcar tracks line the street, and a policeman stands in the road. Notice the absence of any parking meters or signs on the sidewalks. (LHS.)

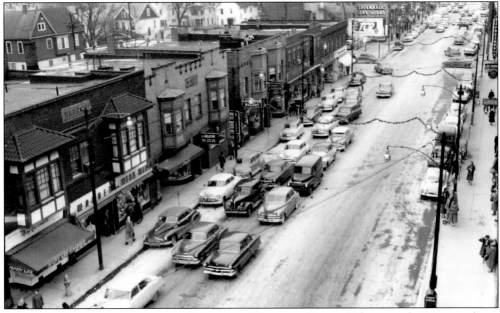

DETROIT AVENUE COMMERCIAL BLOCK AT WARREN ROAD. Taken nearly 30 years later, this 1953 photograph looks east along the commercial block on the north side of Detroit Avenue from Warren Road. The Warren Building anchors the northeast corner. Storefronts include Mary Lee Candies, Warren Men's Wear, and the Lakewood Market. Notice the traffic congestion and the presence of parking meters and signs dotting the sidewalks. (CSU.)

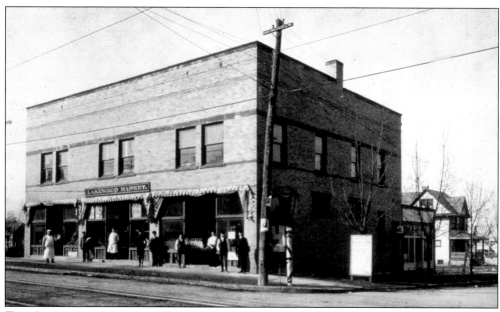

THE LAKEWOOD MARKET. This simple two-story brick building stood on the northwest corner of Detroit Avenue and Warren Road directly across the street from the Detroit-Warren Building. The storefront was the Lakewood Market. The second floor of similar buildings would have been used as apartments or meeting rooms. The building had undergone several extensive remodelings since this photograph was taken c. 1905. (LHS.)

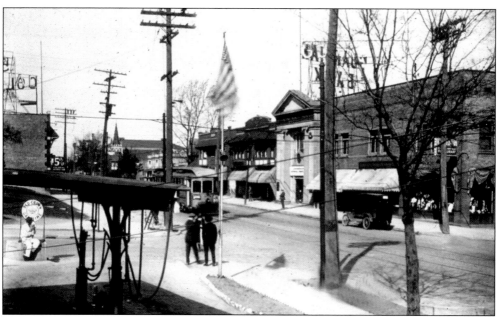

DETROIT AVENUE AT WARREN ROAD LOOKING WEST. In this photograph dated c. 1915 Detroit Avenue is observed from the Red Cross Gas Station as the station pumps and hoses can be seen at front left. The Lakewood Market building has been incorporated into a commercial block featuring the Guardian Bank building with its Greco-Roman façade, columns, triangular peak, and electric rooftop display sign. (LHS.)

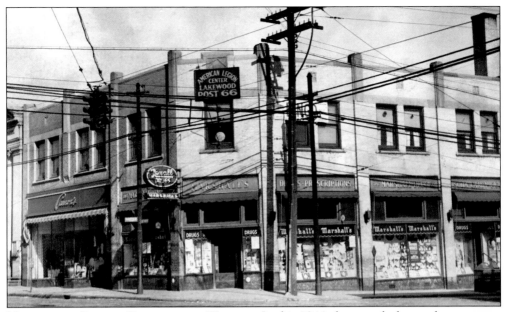

NORTHWEST CORNER DETROIT AND WARREN. In this 1944 photograph the northwest corner commercial block of Detroit Avenue and Warren Road was expanded further along Detroit and winds its way around and down the west side of Warren Road. Anchoring the block is Marshall's Drugstore. Next to Marshall's on the north side of Detroit is Carson's and on the second floor is the American Legion Center of Lakewood, Post 66. (CSU.)

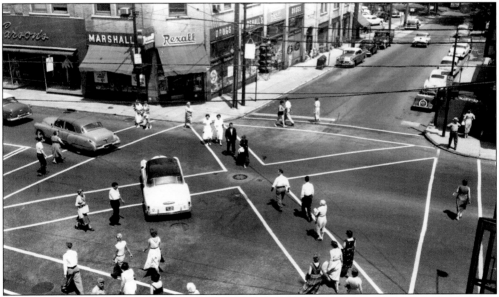

"X" MARKS THE SPOT. The Detroit Avenue and Warren Road intersection is the heart of downtown Lakewood. In 1956 bold, white diagonal crosswalks marked the intersection as vehicular and pedestrian traffic negotiated their way across. The traffic pattern prohibited all left turns except those by cars headed north on Warren. When the light turned red traffic stopped, giving pedestrians the right-of-way to use the crosswalks and proceed directly to any corner. (CSU.)

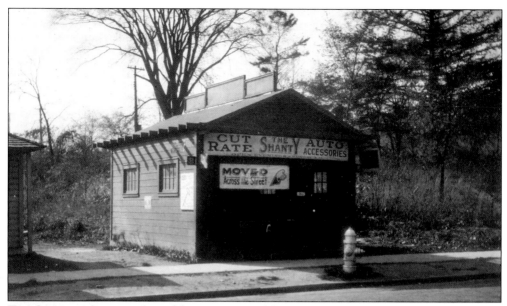

THE ORIGINAL SHANTY. One of the more successful auto parts and accessories establishments in Lakewood was located in a little shack at 14507 Detroit Avenue between Belle and St. Charles Avenue. Called "The Shanty," it was opened in 1918 by Arthur E. Kellogg who turned a profit selling tires and batteries out of his little one-room store. According to the sign, the business had moved across the street. (LHS.)

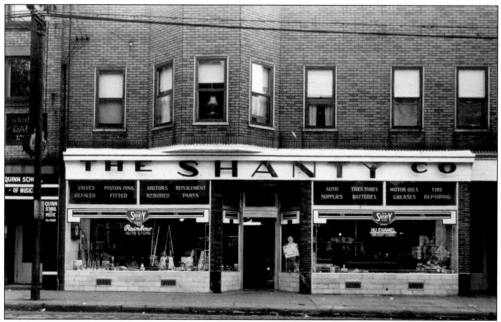

THE SHANTY COMPANY. In 1925 Arthur Kellogg moved The Shanty across the street to its new location at 14614 Detroit Avenue. The expanded store carried an assortment of auto supplies as well as hardware, sporting goods, and even toys. The second floor of the building housed apartments. The Shanty finally closed in 1970, and the building was razed to make way for Lakewood Center North, a 15-story office building. (LHS.)

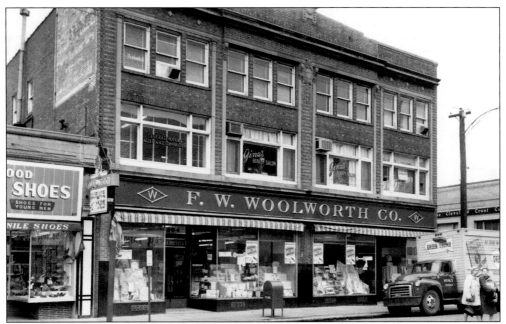

THE F.W. WOOLWORTH COMPANY. The Woolworth Company was a national chain of five-and-dime stores with a Lakewood location at 14904 Detroit Avenue on the corner of Cook Avenue. Woolworth's advertises a "Barrage of Bargains" in its storefront. Among the second floor tenants are Gina's Beauty Salon, the General Motors Acceptance Corporation, and available office space. Next door is Lakewood Juvenile Shoes. It is now the Cook Medical Building. (CSU.)

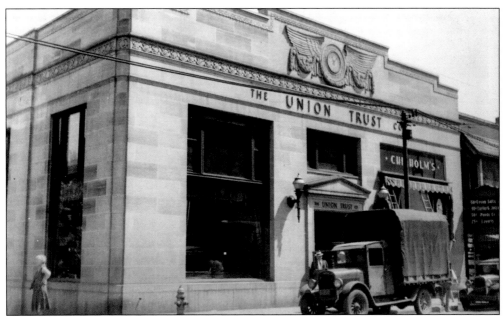

THE UNION TRUST COMPANY. In this 1933 photograph the Union Trust Co. sits across the street from the Woolworth Co. on the northeast corner of Detroit and Cook Avenues. Occupying space next to Union Trust is Chisholm's, which offered cut-rate prices on products like Epsom Salts, 50¢; Ponds Cream, 50¢; and Lavoris for 25¢. (CSU.)

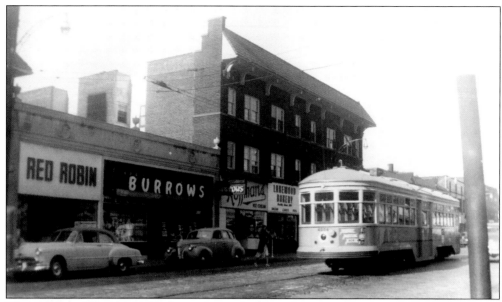

WHERE HAVE THEY GONE? Lakewood once had branch stores of most major retail chains and long-time family-owned businesses all along Detroit Avenue. A woman in this 1951 photographs runs to catch a streetcar passing by some of the more familiar storefront names: Red Robin, a clothing store for women; Burrows, a bookstore; Hoffman's Ice Cream; and Lakewood Bakery. This is also the year the streetcar ceases to run on Detroit Avenue. (CSU.)

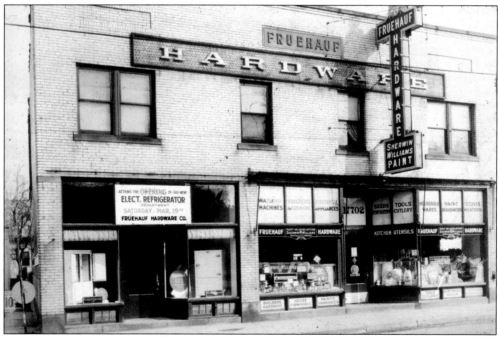

THE FRUEHAUF HARDWARE COMPANY. A Lakewood landmark, the family owned Fruehauf Hardware was located at 17702 Detroit Avenue. It opened for business in 1919 offering general hardware and house furnishings, including electric refrigerators. Fruehauf closed in 1949 when it was purchased by Lossman Motors. The building was later razed. (LHS.)

24

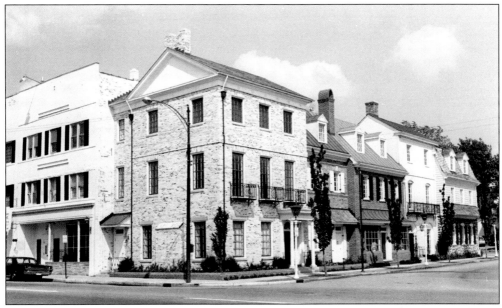

THE GEORGETOWN ROW. The Bonne Bell Cosmetics Company opened at 18515 Detroit Avenue on the southeast corner of Detroit and Graber Drive in western Lakewood. The Bonne Bell Co. anchors the corner of this beautiful commercial block designed in the Georgetown architectural style as seen in this 1969 photograph. Developers attempted to create more than the typical street-level storefront, upper-level office and apartment building combination of many businesses. (CSU.)

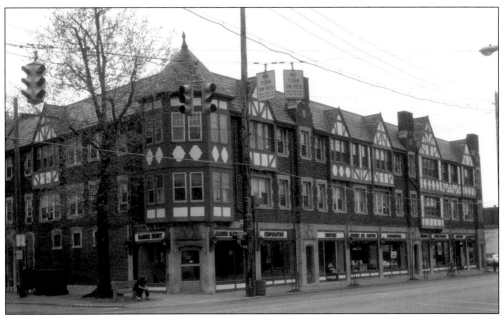

ENGLISH TUDOR COMMERCIAL BLOCK. In 1925 this three-story commercial and apartment block was built on the southwest corner of Detroit Avenue and West Clifton in western Lakewood. This attractive complex displays a successful merger of business and art. Among the first-floor tenants are a management company and an old-fashioned barber shop. (LHS.)

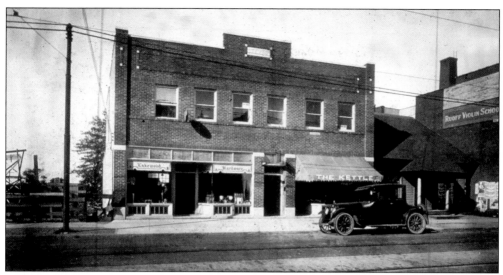

THE STEYER BUILDING. The Steyer Building was a small commercial block located on the north side of Detroit Avenue at 11826 Detroit, just a few blocks from busy West 117th Street. The Steyer Building as seen in this photograph, c.1910, is typical for its time with the two-story, street-level storefront topped by second floor apartments. At ground level was Lakewood Hardware (left) and The Kettle confectioners, now the present location of Maria's Roman Room restaurant. (LHS.)

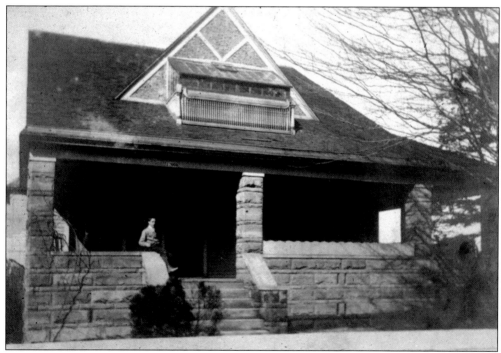

SHADYNOOK. Otto C. Bertold was the third Mayor of the Hamlet of Lakewood, 1899-1901. Seen here c. 1902 is his home, *Shady Nook*, located at 12008 Detroit Avenue. It is a simple structure with a stone front, sloping roof, and open front porch. It was later used for commercial purposes. Mayor Bertold gave the Cuyahoga Telephone Company the right to establish service in Lakewood. (LHS.)

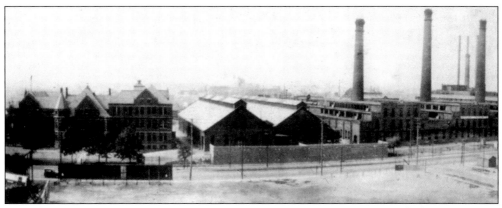

THE NATIONAL CARBON CORPORATION. National Carbon, later Union Carbide Corporation, was a battery manufacturer that opened on Madison Avenue and Magee Street in southeastern Lakewood in 1892. At its height National Carbon was Lakewood's largest employer with more than 2,500 workers. Most of National Carbon's employees were East European immigrants who helped build the city's first neighborhood, originally known as the "Carbon District," then the "Bird's Nest," and now "Bird Town." (LHS.)

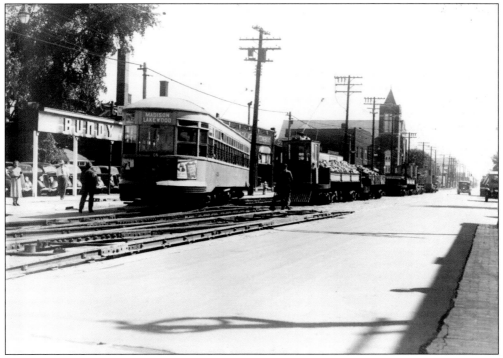

COMMERCE COMES TO SOUTHEAST LAKEWOOD. In this photograph, c. 1939, of the 13300 block of Madison Avenue the Bundy Motor Company, an auto dealership, is seen at left, one of many businesses to appear due to the presence of National Carbon and the streetcar industry, which brought residents to the area. Further on down the block lies Mahall's Bowling and Ss. Peter and Paul Lutheran Church. (Jim Spangler.)

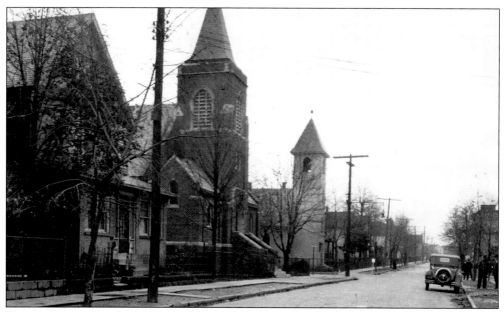

QUAIL AVENUE IN BIRD TOWN. National Carbon owned a large tract of land to the west between Magee and Dowd Streets within walking distance of its factory. The Pleasant Hill Land Company, created by National Carbon, subdivided the land and sold it to National Carbon employees who built neighborhoods, which included churches. Here, in 1931 on Quail Avenue, are Saint Gregory the Theologian Byzantine Catholic Church at left and Calvin Presbyterian Church at right. (LHS.)

ROBIN AVENUE IN BIRD TOWN. National Carbon's plan to create a nearby housing development for its employees was so that the company would not have to depend so heavily on workers who commuted. The company saw to the construction of homes that could be purchased by its employees for a small down payment. Pictured here is a typical multi-family street called Robin Avenue. Note the small front yards and open porches. (CSU.)

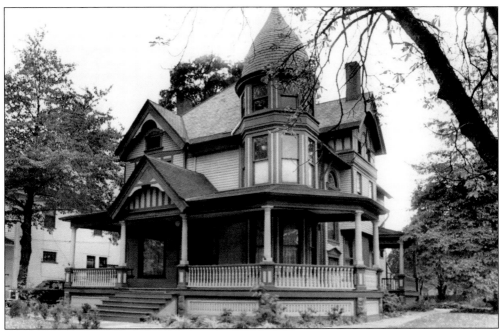

THE HACKENBERG HOUSE. One of Lakewood's landmarks is the Hackenberg House located at 1568 Grace Avenue, a residential street in eastern Lakewood running south from Detroit to Madison Avenue. This house presents a fine example of the Queen Anne architectural style and was placed on the National Register of Historic Places in 1983. Hackenberg was Vice President, Secretary, and Treasurer of the National Carbon Company when he built this home. (LHS.)

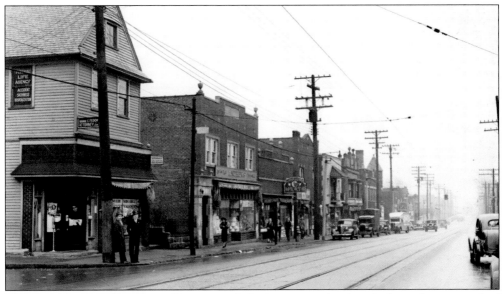

MADISON AVENUE BUSINESS DISTRICT. A business area developed along the east end of Madison Avenue due to both the presence of National Carbon and the streetcar, which brought residents to the area. This 1940 photograph looks east along the north side of Madison Avenue. Businesses include George Fedor's law office, Samuel Stoyanoff's meat market, Andrew Gamary's barbershop, Cort Shoes, Mansky's Shoes, and Fisher Foods Grocery Store. (CSU.)

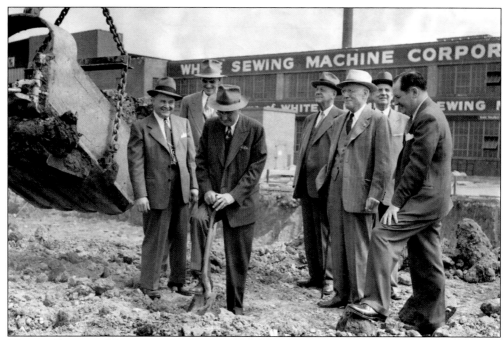

WHITE SEWING MACHINE CORPORATION. The White Sewing Machine Corporation was located at 11770 Berea Road in Lakewood. In this 1950 photograph attending the groundbreaking ceremony for the company's new plant are, from left to right, Vice President E.J. Sebec, plant engineer L.T. McNeal, President A.S. Rodgers, G.L. Harrison, Dr. S.A. Young, W.C. Connelly, and T. Keith Glenman (?), President of the Case Institute. (CSU.)

THE LAKEWOOD ENGINEERING COMPANY. Lakewood Engineering was located on the Lakewood side of Berea Road. At the time this photograph was taken in the 1920s the company employed over 300 workers. (LHS.)

TEMPLAR MOTOR CAR CORPORATION. The Templar Motor Car Corporation was Lakewood's automobile factory that made small, four-cylinder cars from 1917 to 1924. Templar Motors was located on a 20-acre site at 13000 Athens Avenue just south of Madison Park in southeastern Lakewood. At its height Templar employed 600 workers on the line to build four different car models. Bankruptcy ended Templar's run in Lakewood. (LHS.)

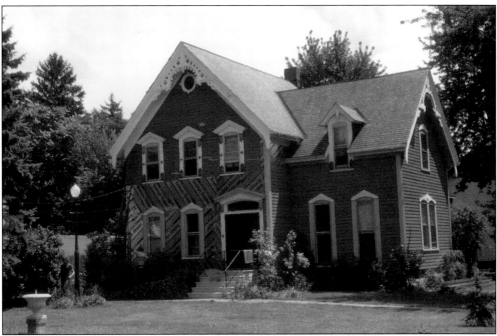

THE ERASTUS DAY HOUSE. This Victorian style residence, being remodeled at 16807 Hilliard Road, was once an elaborate farmhouse. In 1871 Captain Erastus Day, a docks director on Lake Erie, purchased the home for his wife. He then spent a small fortune in renovations using Italianate and Gothic details in the ultimate design. The results qualified the home for inclusion on the National Register of Historic Places in 1979. (LHS.)

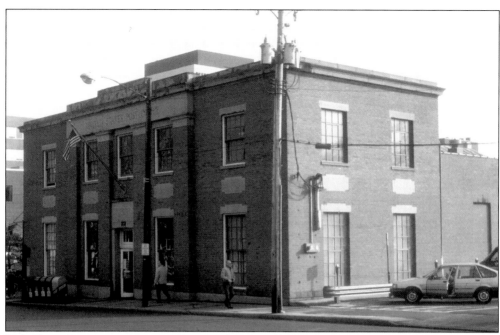

U.S. POST OFFICE ON WARREN ROAD. The post office on Warren Road, just south of Detroit Avenue, was built in 1935 when Lakewood reached a population high of 75,000. It is near the former site of a general store owned by Lucius Dean, the area's first Postmaster General. In 1988 this post office closed and the building is now occupied by a bank. (LHS.)

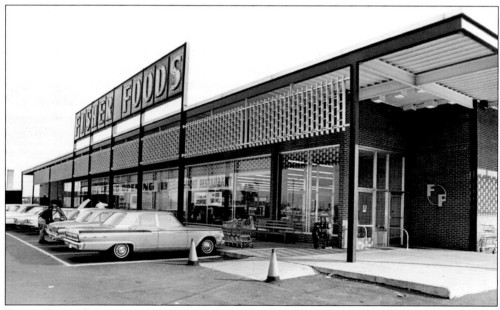

FISHER FOODS SUPERMARKET, C. 1950. Fisher Foods grocery chain opened a store in Lakewood located at 1475 Warren Road south of Detroit Avenue and next to the post office. When Fisher Foods closed this store location the post office relocated there. In the early 1900s this was the site of Lakewood's first high school and later, Wilson Grade School. The Board of Education is across the street. (CSU.)

Two

MUNICIPAL LAKEWOOD

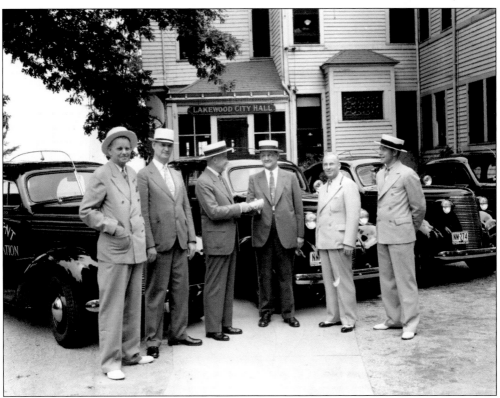

MAYOR AMOS I. KAUFFMAN ACCEPTS DELIVERY OF NEW FLEET. In 1938 Mayor Kauffman (fourth from left) accepted several Chevrolet vehicles for use by the police department. Joining Mayor Kauffman in front of City Hall are, from left to right, Chevrolet City Manager E.C. Butler, Police Chief L.B. Miller, Chevrolet Dealer B.J. Guthery, Mayor Kauffman, Chevrolet Dealer C.H. Scherber, and Chevrolet Zone Manager E.W. Berger. (CSU.)

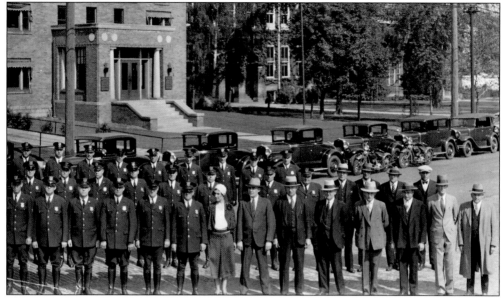

THE LAKEWOOD POLICE DEPARTMENT, 1931. Upon becoming a hamlet Lakewood trustees established a police department consisting of a chief and 11 officers. With a low crime rate, police tasks included vehicle and equipment maintenance. Here department members stand in front of the Lakewood Municipal Court (upper left), 1478 Warren Road. The building to the north, partially hidden behind the trees, is the Lakewood Board of Education building. (CSU.)

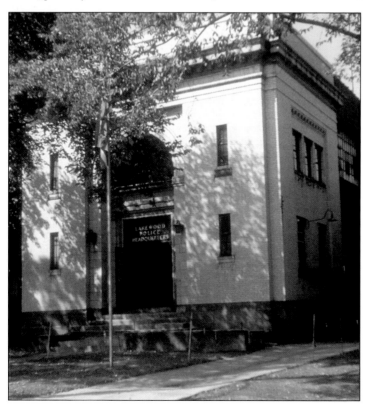

LAKEWOOD POLICE HEADQUARTERS, 1953. The police department moved into the former Cuyahoga Telephone building, 1484 Warren Road, in 1923. Purchased for $25,000, the building was remodeled to add a jail in the basement and a garage for police vehicles in back of the building. It marked the first time police headquarters had a separate and permanent facility. (LHS.)

THE MURDER OF DANIEL KABER. On July 18, 1919 one of Lakewood's most infamous crimes occurred at 12541 Lake Avenue. Daniel Kaber, a 46-year old publisher, was stabbed over 20 times in his bedroom by a pair of hit men hired by his wife, Eva. He died the following day. Also implicated in the murder-for-hire were Kaber's mother-in-law and stepdaughter. Money and passion were the motives given by Eva, who died in prison. (CSU.)

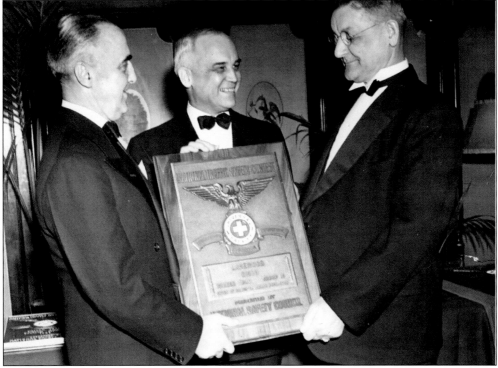

LAKEWOOD WINS AT NINTH ANNUAL NATIONAL SAFETY COUNCIL, 1941. Mayor Amos Kauffman (right) accepted a bronze plaque from Colonel John Stilwell, president of the National Safety Council (left), and U.S. Senator Harold Burton (center). Lakewood won national recognition and first place as one of the safest cities in its population class of 50,000 to 100,000. Among the cities Lakewood bested was Cleveland, whose safety director at the time was Eliot Ness. (CSU.)

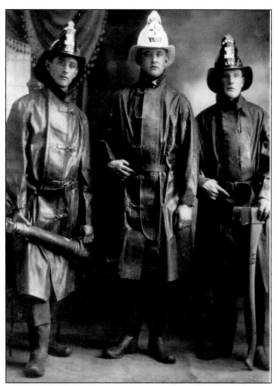

LAKEWOOD FIREFIGHTERS, 1910. When Lakewood's population topped 3,300 in 1902 a volunteer fire department was created. In 1910 the population surpassed 15,000, and the fire department was officially established to include a fire chief, firemen, and volunteers. The chief and firemen received a monthly salary while volunteers were paid hourly per fire. Seen here are some of the original firemen. From left to right are Jake Hennie, Chief Eyner Buhl, and William Curry. (LHS.)

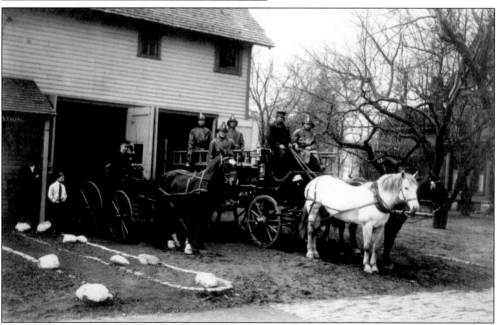

THE HORSE AND BUGGY FIRE BRIGADE OF 1910. Fires were first fought using a hose wagon pulled by horses. These were kept in this barn located behind the first City Hall, the former estate of Jacob H. Tegardine, mayor from 1900-01, on the southwest corner of Detroit and Warren. Standing in the wagon, from left to right, are firemen John Dooley, William Curry, Lester Capell, driver I. Nixon, and volunteer Lester Besch. Chief Eyner Buhl is in the buggy. (LHS.)

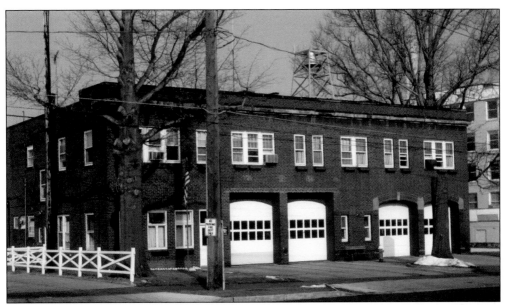

LAKEWOOD FIRE STATION NO. 1 ON WARREN ROAD. This simple two-story brick fire station was built in 1913 on the site of the barn behind City Hall, which formerly housed all fire apparatus. Until the police department established separate headquarters the police and fire departments shared this station with the police housed in the back. This station was later moved to the south side of Madison Avenue just east of Warren. (LHS.)

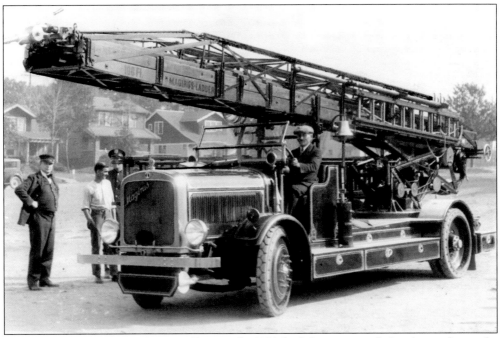

THE MAGIRUS HOOK-AND-LADDER ENGINE. In 1930 firefighters were aided in their task to make Lakewood a fire-safe city with the arrival of this new fire truck featuring a 100-foot extension ladder. By this time the fire department had expanded to include 67 regular firemen housed in three stations located on Warren Road, Madison Avenue, and Hopkins Avenue. (CSU.)

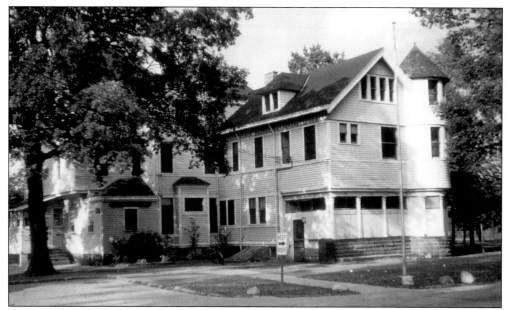

THE LAKEWOOD PARK CITY HALL. The estate of Robert Russell Rhodes, son of Daniel P. and brother of James Ford Rhodes, became City Hall after it was purchased by Lakewood in 1918 for $214,500. Known as "The Hickories," this luxurious estate was built along the lakeshore in what is now Lakewood Park. It was Louis E. Hill, mayor-elect in 1920, who converted the Rhodes estate into a municipal building. (LHS.)

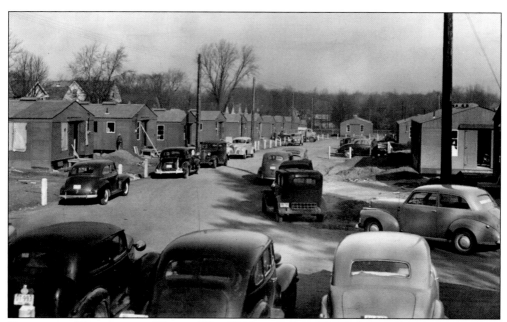

TEMPORARY HOUSING FOR WORLD WAR II VETERANS, 1946. Lakewood's Memorial Park at Detroit and Alameda Avenues was the site of these temporary housing units built for veterans and their families. Fifty-two family barrack-like units were built for $50,000. Residents paid $42 a month for rent, which included gas and electricity. This park later became the site of Lakewood's City Hall and Municipal Court. (CSU.)

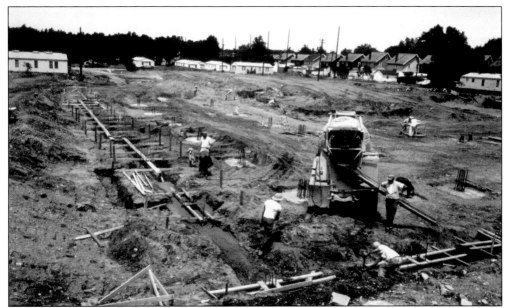

LAKEWOOD BUILDS A CITY HALL, 1958. The foundation for Lakewood's new city hall and municipal court building is being readied in Memorial Park at Detroit and Alameda Avenues. Funding was provided when a $1.75 million bond issue received voter approval. The two-story brick and stone building was designed by the architectural firm of Garfield, Harris, Shaffer, Flynn, and Williams. The Rhodes house was demolished when this facility opened. (LHS.)

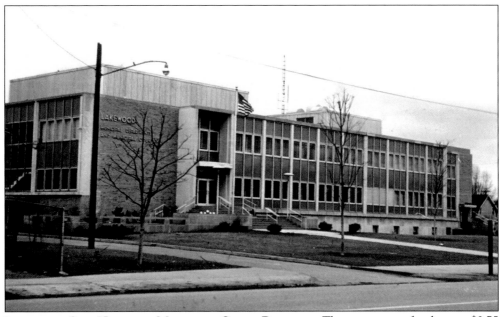

LAKEWOOD CITY HALL AND MUNICIPAL COURT BUILDING. The cornerstone for the new $2.75 million city hall was laid in 1958 during the administration of Mayor Frank Celeste. Located at 12650 Detroit Avenue, this was the first new municipal building ever constructed in Lakewood. It would house the police department and jail, courthouse, city council, and the mayor's office. The second floor contains an auditorium with a seating capacity of 600 to host civic events. (LHS.)

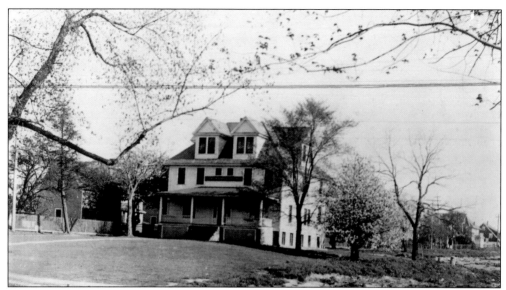

THE HEALING HOUSE THAT GRABER BUILT. In 1907 Lakewood had been a village for three years with its population growing steadily when Dr. C. Lee Graber mortgaged his own home to help finance the city's first hospital. He built this 15-bed hospital on the southeast corner of Detroit and Belle Avenues as a residence so it could be used as one should the hospital fail. It was razed in 1948. (CSU.)

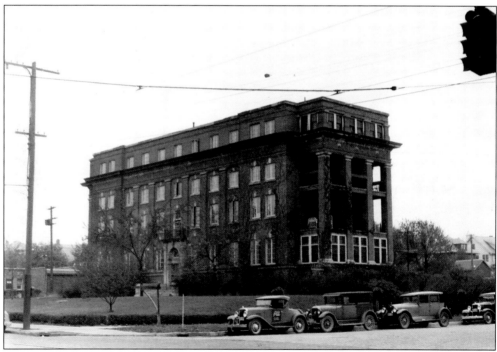

LAKEWOOD HOSPITAL BEGINS TO GROW. In 1917 this four-story brick hospital at 14519 Detroit Avenue, was built in front of the original 15-bed hospital, which was then used to house nursing students until 1937. Dr. Graber continued as Chief of Surgery until his retirement in 1948. He died in 1954 at the age of 80. (CSU.)

THE LAKEWOOD HOSPITAL. In 1931 the City took over the private hospital. In 1940 it underwent the first of several remodeling and expansion projects to give Lakewood its present 400-bed facility. In this photograph on the left, behind the sign, the second brick hospital can be seen as the anchor with new additions extending down Belle Avenue. Lakewood Hospital is presently Lakewood's largest employer. (CSU.)

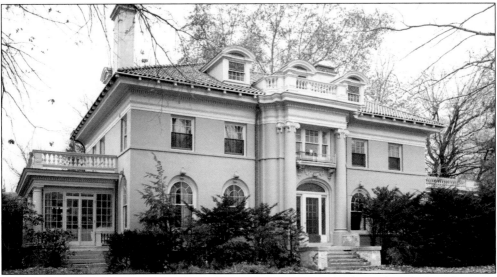

DESIGNERS' HOPE HOUSE. Located on the southwest corner of Lake and Nicholson Avenues, this was the first designer show house on Cleveland's west side. This three-story, 26-room mansion was built around 1910 and had fallen into disrepair. A partnership between the American Cancer Society and the American Society of Interior Designers paid for expert restoration by top interior designers. All proceeds from house tours benefited each organization. (CSU.)

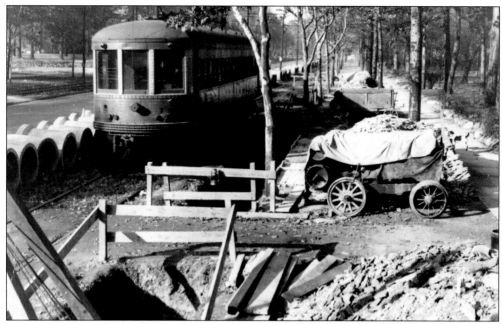

SEWER CONSTRUCTION, NOVEMBER 13, 1936. Traveling westbound, a Lake Shore Electric interurban passes along sewer construction work on the north side of Clifton Boulevard across from Hathaway Avenue. Note the trees, many apparently newly planted, that line Clifton and would help establish Lakewood's image as one of Ohio's tree cities. (Jim Spangler.)

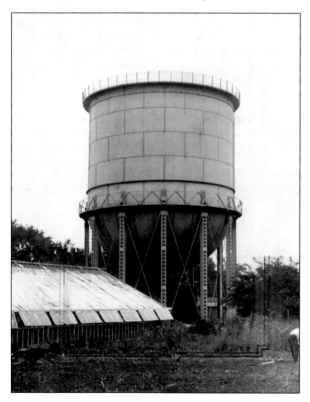

THE WATER TOWER. Built *c.* 1910 for just under $9,000, this water tower stood on Warren Road south of Detroit Avenue near Fire Station No. 1. The 80-foot tower was built to provide for Lakewood residents when Cleveland was unable to meet local water pressure demands. The tower was taken down in 1934, and Cleveland remained the sole provider of water. (CSU.)

NATURAL GAS WELL IN LAKEWOOD PARK, 1956. Mayor Frank P. Celeste peers down a private gas well discovered in 1924. Lakewood once had over 200 active wells drilled during the gas boom years of 1914 and 1915. The majority of these gas fields were discovered along the shoreline particularly in the area known as the Gold Coast. At its height gas production was 15 million cubic feet daily. (CSU.)

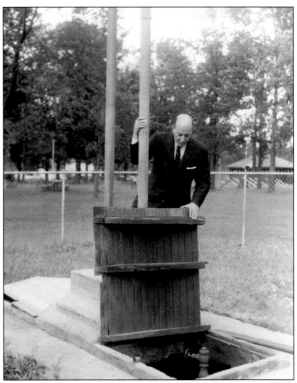

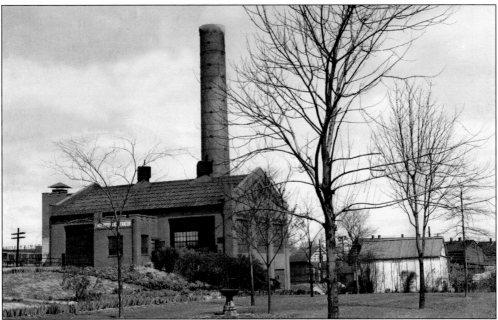

THE LAKEWOOD INCINERATOR, 1946. The Lakewood Incinerator occupied five acres at 12920 Berea Road in southeastern Lakewood. It was built during the administration of Mayor Edward A. Wiegand, 1924-1932, for $100,000 to dispose of refuse in a sanitary and efficient manner. In 1981 the incinerator closed after the Environmental Protection Agency said it caused air pollution. The building is now used as a refuse and recycling center. (CSU.)

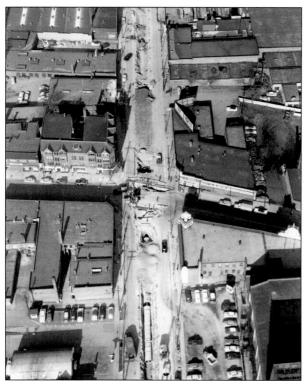

THE SEWER GAS EXPLOSION SEPTEMBER 11, 1953. A series of explosions, apparently caused by extreme sewer gas pressure, ripped open a one-mile stretch of West 117th Street extending from Lake Avenue south to Berea Road. The West 117th Street and Detroit Avenue intersection is seen in the center of this aerial view. Lakewood can be seen at the left of West 117th Street, which was known as Highland Avenue on the Lakewood side. (CSU.)

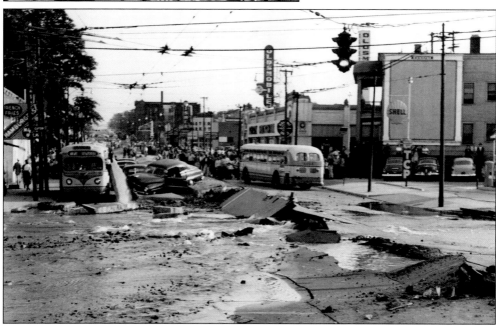

SEWER GAS EXPLOSION DAMAGE ON WEST 117TH STREET. The tremendous blast of the gas explosion destroyed motor vehicles and other property all along Lakewood's eastern border. Dozens of people were injured, and there was one fatality. Seen here is the intersection of West 117th Street and Clifton Boulevard looking south along West 117th Street shortly after the disaster. (CSU.)

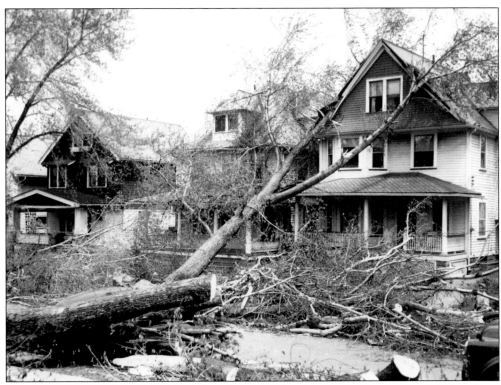

THE 1956 WINDSTORM. On May 12, 1956 a severe thunderstorm and high winds swept through Lakewood. When the storm had subsided Lakewood had lost about 3,000 trees resulting in more than 50 streets being closed. Damage estimates exceeded $3 million. The Ohio National Guard and over 200 civil defense volunteers came to help remove over 14,000 tons of debris. This photograph shows some of the damage on Hall Avenue. (CSU.)

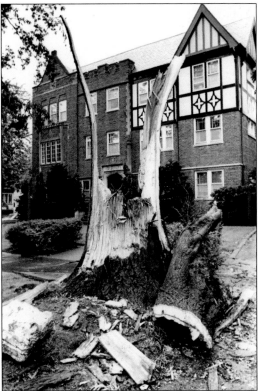

THE JULY 4, 1969 STORM. As Lakewood residents participated in Fourth of July festivities a deadly squall line of storms swept suddenly across northeast Ohio. Lakewood Park was hit especially hard as the storm uprooted trees, and limbs and trees were split apart, as the one seen in this photograph, of the 15400 block of Clifton Boulevard. Many people were injured, and there was one fatality. (CSU.)

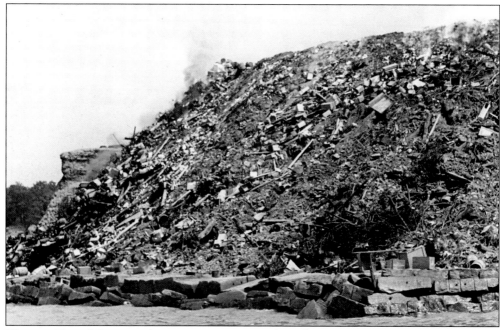

WHAT A DUMP! Progress always carries a price and, in this case, it was garbage polluting the shoreline. This 1928 photograph shows how Lakewood disposed of its refuse. Garbage and dump trucks were used to haul trash, which included tin cans and other salvageable materials to this landfill, which covers approximately four acres in the rear of Lakewood Park near the shoreline. The incinerator helped curtail the problem. (CSU.)

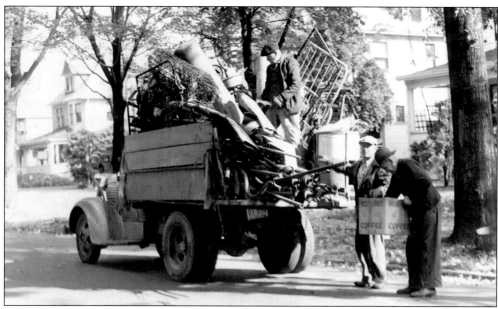

COLLECTING TRASH FOR CASH, 1942. During World War II Lakewood encouraged residents to collect salvageable waste materials to aid the war effort and provide additional funds for public use. From 1942 to 1947 such collections brought Lakewood nearly $15,000 in extra funds. Here residents of Belle Avenue load a pick-up truck with scrap metal for recycling. (CSU.)

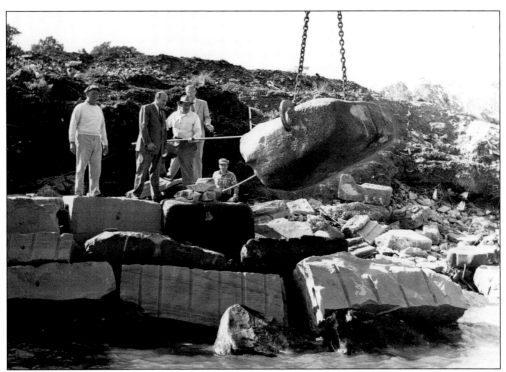

THE BREAKWALL ALONG LAKEWOOD PARK, 1956. A tugboat captures Mayor Frank P. Celeste as he visits with workers constructing the breakwall along Lakewood Park's western shoreline. A huge 14-ton pre-cut module or boulder is slowly lowered by a crane barge and then steadily guided into place by workers in an effort to curtail erosion, an ongoing problem for Lakewood. (CSU.)

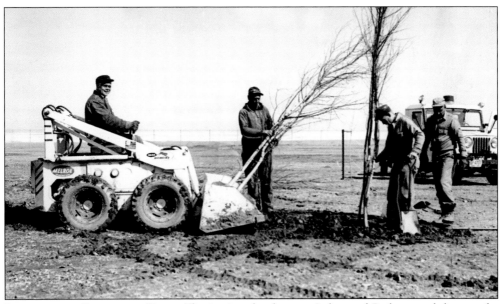

LANDSCAPING LAKEWOOD PARK. Eliminating the dump at Lakewood Park opened the area for recreational use. Here in this 1965 photograph city workers are busy planting some 50 white birch trees. From left to right are Pete Belenka, Gus Melzer, Jan Jantosik, and George Pangral. (CSU.)

47

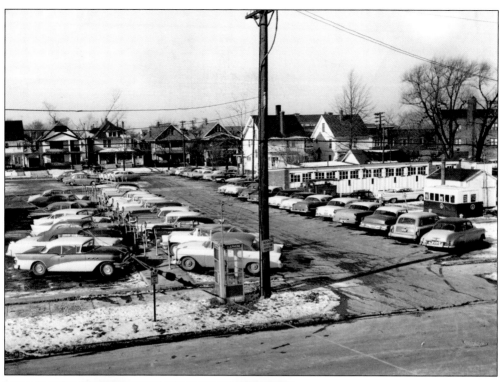

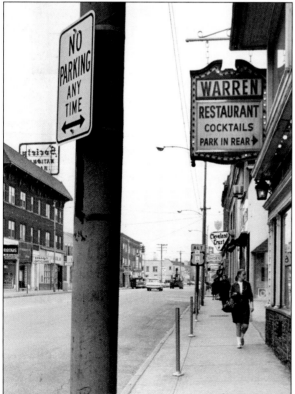

MUNICIPAL PARKING AT "WEST LOT" IN 1958. Parking always has been a problem for densely populated Lakewood. Here is the parking lot once located between Warren Road and Victoria Avenue, due south of Detroit Avenue. This metered 127-car lot rarely had any openings. It would become the site of Lakewood City Center. (CSU.)

NO PARKING AT ANY TIME! In a desperate move to ease downtown traffic congestion a trial parking ban went into effect in April 1968 on Detroit Avenue. The ban covered a three-block stretch from St. Charles to Gladys Avenues as the City and the area merchants' association joined together to improve traffic flow. In order to underscore the seriousness of the problem parking meter heads were removed. (CSU.)

Three

TRANSPORTATION

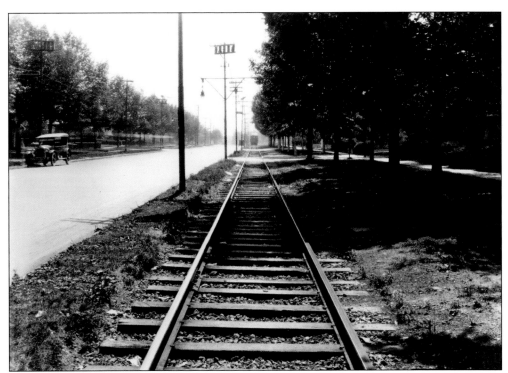

LAKE SHORE ELECTRIC RAILWAY ON CLIFTON BOULEVARD, 1927. The opening of the
Detroit-Superior Bridge on December 25, 1917, proved to be the single greatest spur to the
development of Lakewood. Travel between downtown Cleveland to western suburbs became
easier, and streetcar rails such as seen here traveled through the city spurring the popularity of
interurban and streetcar transportation. (CSU.)

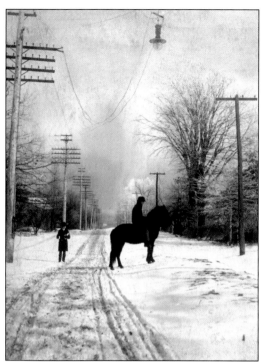

HORSEMAN ON WARREN ROAD. Horses remained the primary means of getting around town until motorized vehicles took over. One of the first laws passed after Lakewood became a hamlet made speeds exceeding eight mph by horse or other animal punishable by a $25.00 fine or 30 days in jail. This photograph was taken from Franklin Boulevard looking north along Warren Road, c. 1904. (LHS.)

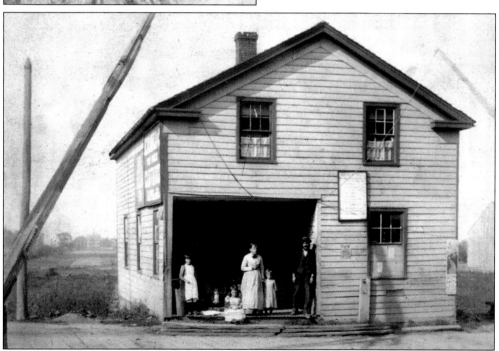

DETROIT AVENUE TOLL HOUSE. This modest frame house was built about 1850 by The Plank Road Company. It stood on the north side of Detroit at what is now Warren Road and was one of three tollhouses along Detroit Road east of the Rocky River Valley. The house was moved when the tolls were lifted and Detroit became a "free street" in 1901. It is now located at 1325 Cook Avenue. (LHS.)

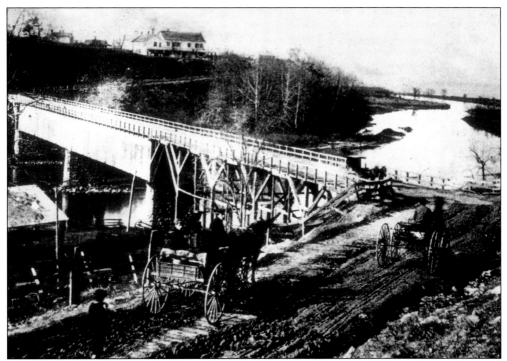

THE ROCKY RIVER BRIDGE. Early travel from Lakewood to Rocky River was difficult due to muddy, cumbersome roads. During the 1820s a simple wooden bridge was built across the Rocky River Valley, eliminating the need to ferry across. It was replaced in the early 1850s with this bridge. Travelers head for the Silverthorn Tavern, at top left, a popular rest stop on the west bank of the Rocky River. (LHS.)

LAKE SHORE ELECTRIC TICKET OFFICE. The Lake Shore Electric Interurban ticket office was located on the northeast corner of Detroit and Sloane Avenues, next door to the "High Bridge Park" Billiard Parlor. The intersection of Edanola and Sloane Avenue can be seen on the left in this 1910 photograph. (CSU.)

INTERURBAN ON CLIFTON BOULEVARD. When the Lake Shore Electric Railway began operations through Lakewood it used the Detroit Avenue streetcar tracks. In 1903 the Lake Shore Electric switched to the Clifton Boulevard streetcar tracks. In this photograph a two-car Lake Shore Electric train is traveling westbound on Clifton. Top speeds of 50-60mph made the interurban a popular form of travel between Ohio cities to the west. (LHS.)

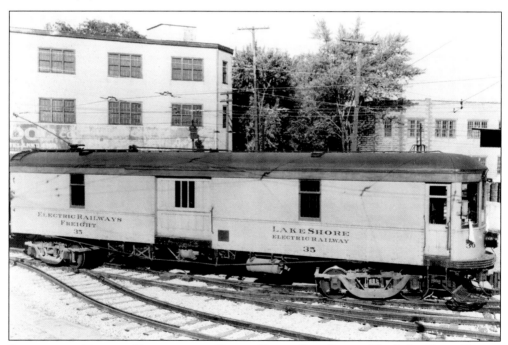

INTERURBAN FREIGHT YARD AT THE ROCKY RIVER CAR BARN. The Lake Shore Electric Railway Company used the Rocky River car barns at the west end of Lakewood when not in use. The interurban provided freight service in addition to passenger service as seen in this 1935 photograph of an electric railway freight car parked at the car barn. (CSU.)

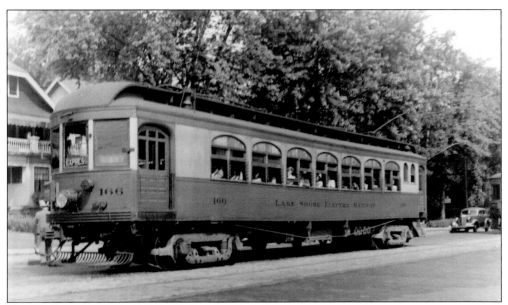

THE LAKE SHORE ELECTRIC RAILWAY. In 1901 the interurban electric trolley or "street trains" were put into operation by The Lake Shore Electric Railway Company. The interurban ran between Cleveland, Lorain, Huron, Sandusky, Fremont, and Toledo at top speeds making it a popular form of travel. In this photograph is outbound Lake Shore Electric Railway car 166 westbound on Sloane Avenue on the eastern approach to the Rocky River Bridge. (CSU.)

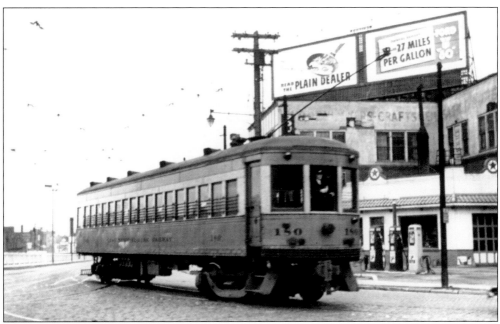

LAKE SHORE ELECTRIC RAILWAY ON SLOANE AVENUE. Seen here is inbound Lake Shore Electric Railway car 180 as it prepares to make a turn onto Sloane Avenue from Detroit Avenue. Unlike the streetcar that made frequent stops, the interurban had only one stop in Lakewood at the intersection seen here of Sloane and Detroit where the 180 is coming off the Rocky River Bridge. (CSU.)

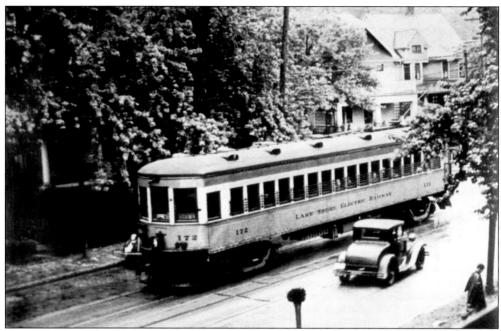

END OF THE LAKE SHORE ELECTRIC LINE. The demise of interurban service foreshadowed that of the streetcar as the use of personal automobiles and passenger buses soared. LSE car 172 is seen here on its final run heading east on Sloane Avenue on May 14, 1938, the last day of operation for the Lake Shore Electric Railway line. It was eight miles from Sloane and Detroit Avenues to Cleveland's Public Square. (LHS.)

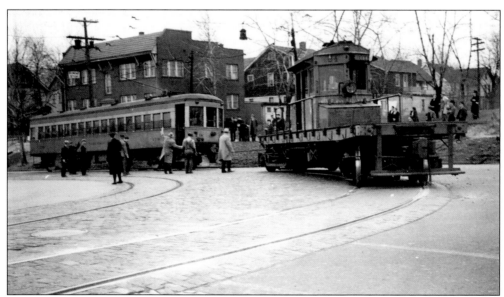

WRECK OF LSE 179. There were nearly 250 accidents and other incidents recorded during the nearly 45 years history of the Lake Shore Electric Railway. One of the last recorded accidents, and the last one in Lakewood, occurred April 14, 1937, when LSE car 179 derailed at the intersection of Sloane Avenue and West Clifton Boulevard. The car remained in service to the end of the Lake Shore's run. (CSU.)

BUNTS ROAD NORTH OF MADISON AVENUE. Bunts Road was named for Harry C. Bunts, a Cleveland lawyer who had invested in the property that was once part of Dr. Jared P. Kirtland's estate. In 1919 Bunts was typical of Lakewood's dirt roads of that period: muddy with ruts made from the tire tracks of vehicles like the one seen in the upper right of the photograph. (LHS.)

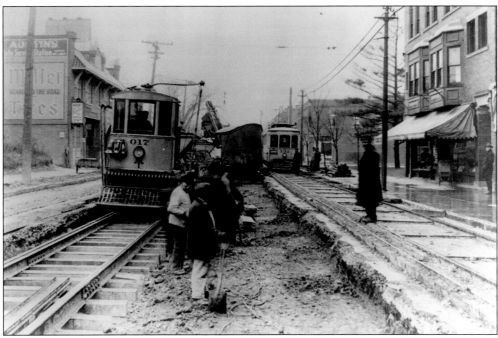

STREETCAR MAINTENANCE CREW ON DETROIT AVENUE. Streetcar tracks once traced the main roadways of Lakewood. This photograph, taken December 16, 1916, looks west along Detroit Avenue from Belle Avenue. Cleveland Railway Company maintenance crews loaded dumpcars by hand as they moved away earth and paving blocks to build temporary tracks when repairs were needed. An electric shovel was used to lift rails and ties into place. (Jim Spangler.)

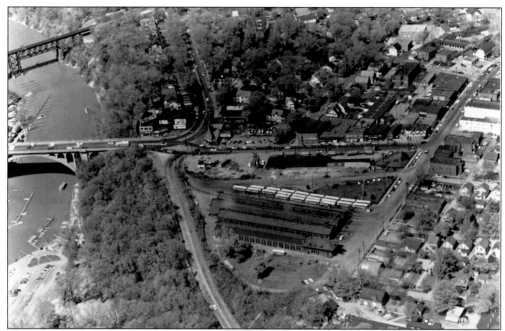

THE ROCKY RIVER CAR BARNS. Also called the Detroit Avenue Car Barns, they opened in 1899 at the western end of Detroit Avenue next to the Rocky River Valley. Streetcars from the Detroit Avenue and Clifton Boulevard lines were housed in the barns seen in this 1955 aerial photograph. The Rocky River Bridge is at mid-left, and the Nickel Plate Railroad Bridge is at top left. (CSU.)

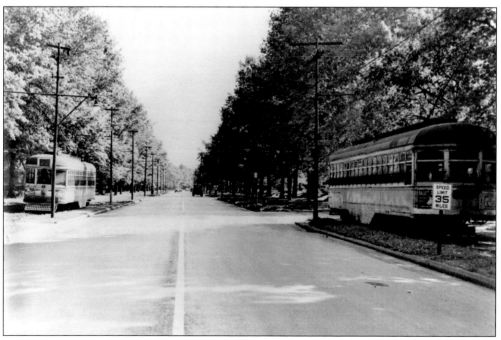

CTS STREETCARS PASSING ON CLIFTON. This October 1947 photograph shows outbound CTS streetcar 1239, on the left, heading west, and inbound streetcar 1125, on the right, heading east on Clifton Boulevard at Ethel Avenue. (Bruce Young.)

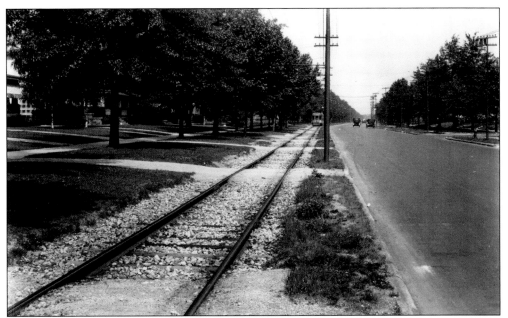

CLIFTON BOULEVARD STREETCAR LINE. The Clifton Boulevard streetcar line began operations from Public Square in downtown Cleveland in 1902. This 1927 photograph shows a streetcar traveling along Clifton. The Clifton tracks differed from those on the Madison or Detroit lines in that they were laid over tree lawns alongside the road instead of imbedded in the road. This often created problems for residents leaving their driveways. (Bruce Young.)

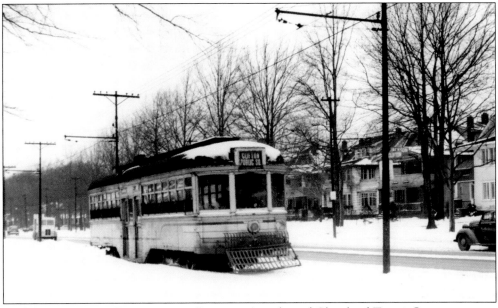

CTS STREETCAR AT JACKSON AND CLIFTON. An inbound Cleveland Transit System streetcar nears Jackson Avenue in northeastern Lakewood as it travels east along Clifton Boulevard towards Public Square in downtown Cleveland. During the winter months streetcars were equipped with snow-scoopers, grated metal aprons that were used to clear a path for the streetcars to run smoothly over the tracks. (Bruce Young.)

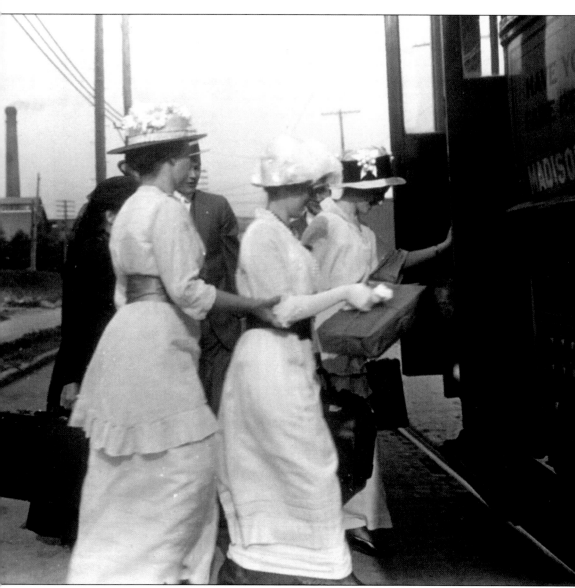

WOMEN BOARDING STREETCAR. Riding the early streetcars was often an exciting event. In this photograph, c. 1910, ladies' fashions are modeled by three young women eagerly boarding a Madison Avenue streetcar, carrying packages neatly wrapped after a shopping trip. Printed on the side of the entrance is this reminder: "Have Your Fare Ready." The Madison Avenue streetcar line was one of three in Lakewood, along with the Detroit Avenue and the Clifton Boulevard lines. Service on the Madison line began in 1893 from downtown Cleveland, but did not cross West 117th Street into Lakewood until 1917 when it was extended first to Belle Avenue, near Lakewood Park, and then to Riverside Drive in western Lakewood. The Madison Avenue streetcar route contributed greatly to the development of the residential and commercial district along Madison Avenue, particularly in southeastern Lakewood, which is often called the Bird Town District. (LHS.)

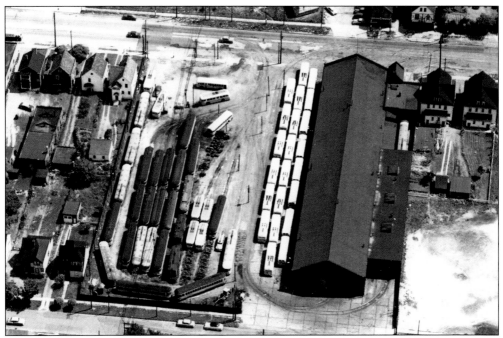

MADISON AVENUE STREETCAR BARNS. When not in use streetcars were housed at one of two yards in Lakewood, one on Madison Avenue and the other on Detroit Avenue. In this 1953 aerial photograph the barns and streetcars located at West 117th Street and Madison Avenue are visible. The Madison Avenue barns were built in 1895. (CSU.)

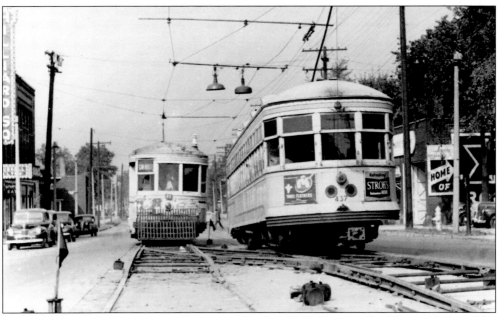

STREETCARS AT DETROIT AND HILLIARD. In this 1946 photograph Cleveland *Peter Witt* streetcars 437, on the right, and streetcar 929, on the left, approach the intersection of Madison Avenue and Hilliard Boulevard. Notice the marquee for the Hilliard Square Theater on the left. (Jim Spangler.)

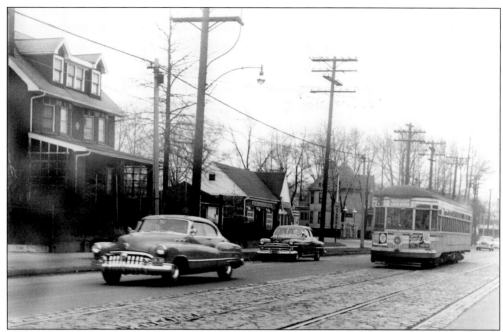

SHARING THE ROAD. This 1953 photograph of Madison Avenue illustrates how streetcars continued to travel over the original brick roadway even after the other lanes were paved with asphalt for motorized vehicle traffic. At the center of the photograph is Don's Shell Service Station on the northwest corner of Madison and Robinwood Avenue. The remodeled building is presently used for medical offices. (Jim Spangler.)

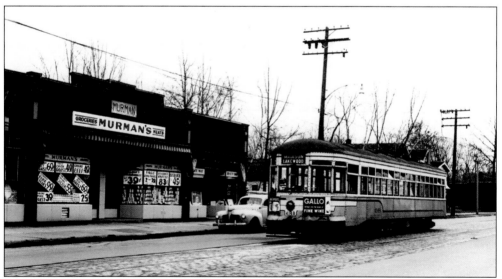

MURMAN'S MARKET, 1953. Many small, family-owned businesses sprang-up along Madison Avenue due to the increased traffic flow and growth of neighborhoods attributed to the streetcar. Westbound CTS streetcar 4148 passes Murman's Market, located at 17510 Madison Avenue, less than a block away from the Spring Garden turnaround. Store signs advertise cube steaks at 99¢/lb., standing rib roast at 69¢/lb., frying chickens at 59¢/lb., and loin pork roast for 39¢/lb. (Bruce Young.)

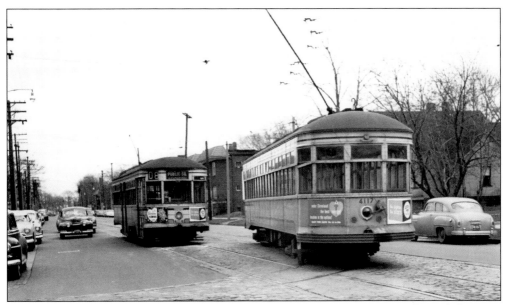

SPRING GARDEN AVENUE TURNAROUND. Spring Garden Avenue runs north-south between Detroit and Madison Avenue. Madison Avenue streetcars used a "wye" or y-shaped track layout at the south end of Spring Garden as a turnaround for their return trip downtown. Here inbound CTS streetcar 4117 departs from Spring Garden as outbound CTS streetcar 4116 waits to enter the turnaround, 1953. (Jim Spangler.)

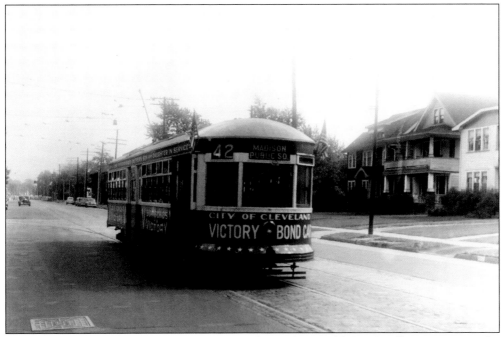

VICTORY BOND CAR. Streetcars were recruited into the World War II effort to promote the sale of Victory Bonds. This 1943 photograph shows the Victory Bond streetcar traveling west on Madison Avenue near the Spring Garden turnaround. The three homes on the south side of Madison were later razed to make way for the Attache Apartments. (Jim Spangler.)

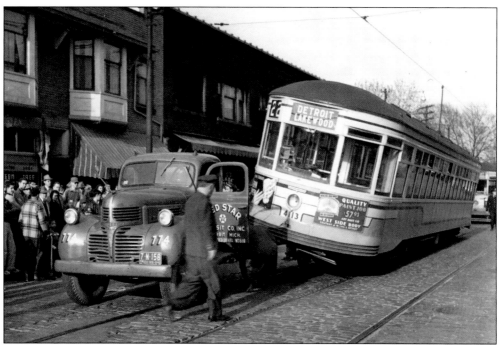

A Dog-Day Afternoon. Sometimes trucks and streetcars would meet by accident. In 1951 a stray dog caused snarled traffic when the driver of the pick-up truck on Detroit Avenue swerved to avoid the animal and in so doing, caused outbound CTS streetcar 4113 to jump the tracks and climb up onto the flatbed. No one was injured, but traffic was stopped at Detroit and Lakewood Avenues for one half of an hour. (CSU.)

Covering Their Tracks. The Detroit Avenue streetcar line ceased operations on August 25, 1951. Shortly thereafter a dispute arose between the City and the contractor hired to replace the rails. The City wanted the rails covered with seven inches of concrete while the contractor argued for four inches plus three inches of old granite paving blocks. The photograph shows the re-paving work at Detroit Avenue and Webb Road. (CSU.)

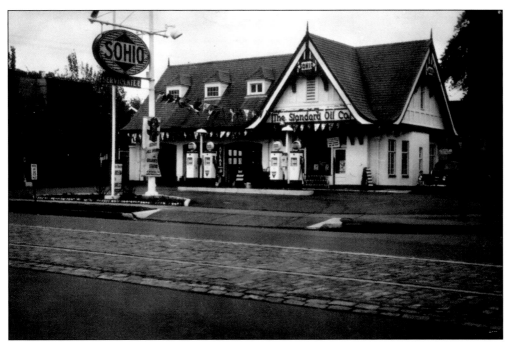

SOHIO SERVICE STATION. As automobile traffic increased so, too, did the appearance of corner gas stations like this Standard Oil Co. service center located on Detroit Avenue. (LHS.)

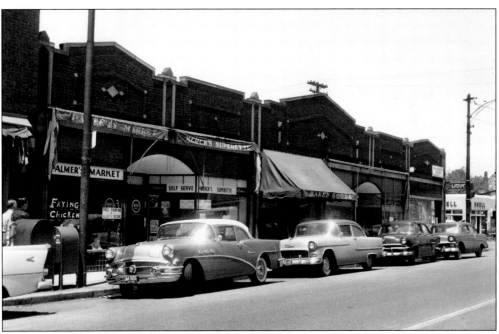

PARKING ALONG DETROIT AVENUE. Motorists traveling on Detroit Avenue especially during business hours find a lack of available parking. This 1956 photograph shows cars parked in front of Palmer's Market, Merck's Superette, the Garret Shop, and the Riverwood Tavern on the north side of Detroit Avenue, west of Riverside Drive. Signs posted on the windows of Palmer's and Merck's remind shoppers that free parking is available in the rear of the stores. (CSU.)

LAKEWOOD HEIGHTS BOULEVARD. At one time Lakewood Heights Boulevard was an east-west road extending from Berea Road to Riverside Drive. Now it is divided into sections due to I-90. As seen in this 1956 photograph Lakewood Heights Boulevard once crossed over the New York Central Railroad tracks west of Berea Road. Lakewood would later build an overpass over the railroad tracks to prevent car-train accidents. (CSU.)

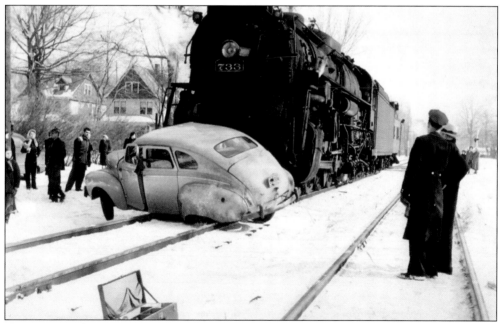

TRAIN-AUTO COLLISION ON THE NICKEL PLATE TRACKS. NKP locomotive 733 finally stopped after striking the passenger side of a 1937 Ford and pushing it along the tracks after the automobile failed to heed the railroad crossing warning signal. As seen in this 1948 photograph Lakewood had parallel railroad tracks running through town. In the 1990s Norfolk & Western Railroad agreed to remove one set of tracks in an effort to reduce the risk of such accidents. (LHS.)

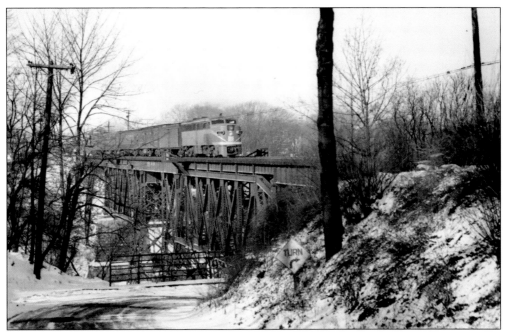

THE NICKEL PLATE ROAD. NKP locomotive 181 pulls an inbound commuter passenger train across the Rocky River Valley into Lakewood as seen from near Sloane Avenue in this 1949 photograph. The NKP purchased the Rocky River Railroad, often referred to as The Dummy Railroad, in 1881. The following year the NKP built a multi-span iron viaduct across the Rocky River Valley. It was replaced by the present bridge in 1907. (CSU.)

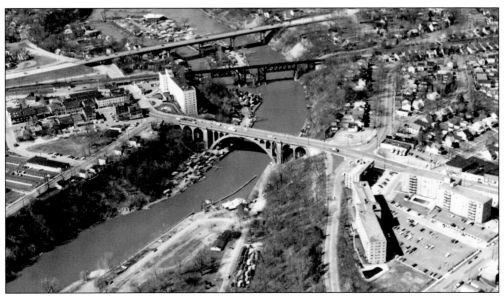

THE ROCKY RIVER BRIDGE, 1971. This 700-foot concrete span bridge featured a 280-foot central arch of un-reinforced concrete, the longest of its kind in the world. The aerial photograph shows the Rocky River Bridge in foreground, the Nickel Plate Railway Bridge in center, and the Clifton Park Bridge in the background. All three bridges span the Rocky River Valley and connect Lakewood, at right, with Rocky River, at left. (CSU.)

EASTERN APPROACH TO THE ROCKY RIVER BRIDGE. Seen in this photograph taken in the early 1900s is the intersection of Detroit Avenue and Sloane Avenue while looking towards the northwest corner which is now the site of Harbor View Apartments. (CSU.)

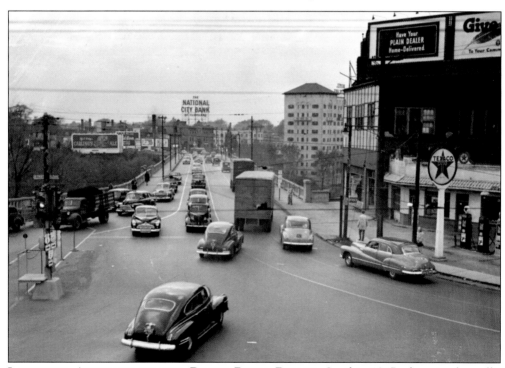

LAKEWOOD APPROACH TO THE ROCKY RIVER BRIDGE. In this 1947 photograph traffic approaches the Rocky River Bridge heading west towards Rocky River at the intersection of Detroit and Sloane Avenues. (CSU.)

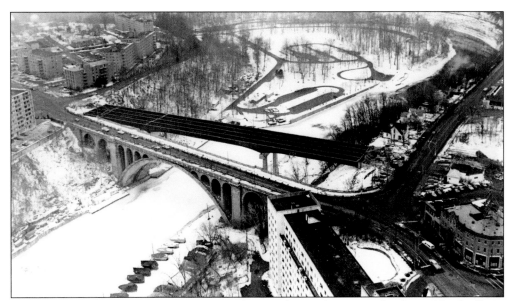

THE NEW ROCKY RIVER BRIDGE, 1980. The aerial view from over the City of Rocky River looks south at the construction on the present Rocky River Bridge. Lakewood is on the left. The new bridge was built nearly parallel to the 700-foot concrete span it was to replace. The old Rocky River Bridge was built in 1910 as motorized vehicles and an increasing population required a sturdier bridge to support the traffic flow. (CSU.)

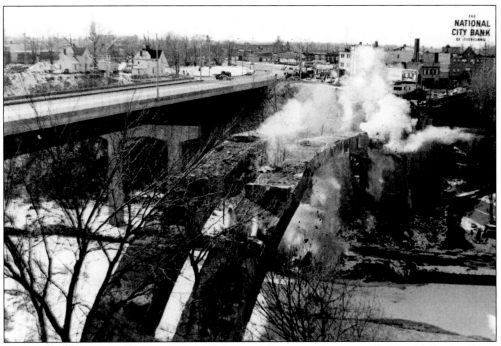

DEMOLITION OF THE ROCKY RIVER BRIDGE. The concrete span of the old Rocky River Bridge across the Rocky River Valley was demolished with dynamite after the new bridge was completed. Destruction of the 1910 bridge drew many to publicly protest what they viewed as the loss of a historic landmark. (CSU.)

AERIAL VIEW OF PROPOSED INTERSTATE 90 ROUTE. This is an aerial view taken in 1968 looking east along the proposed route for Interstate 90 through southwestern Lakewood. The two streets running east-west are Lakewood Heights Boulevard, to the right, and Delaware Avenue to the left. The streets running north-south are, from the bottom to the top, McKinley Avenue, Niagara Drive, and Concord Drive. The concrete span of the Hilliard Road Bridge can be seen in the upper left. The Hilliard Road Bridge, which was completed in 1926, opened a southern traffic route between Lakewood and Rocky River. Now the two western suburbs were connected by three bridges: the Rocky River Bridge, the Clifton Park Bridge, and the Hilliard Road Bridge. (CSU.)

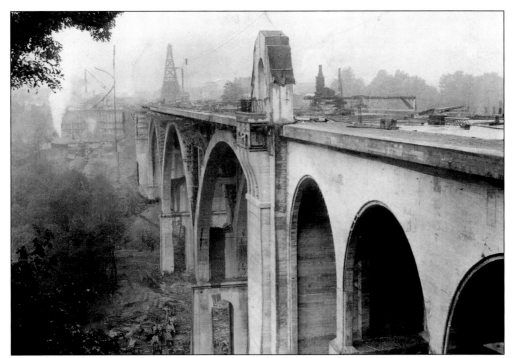

THE HILLIARD ROAD BRIDGE CONSTRUCTION. The Hilliard Road Bridge connected the southern part of Lakewood to Rocky River. Hilliard Road runs west-southwest through western Lakewood beginning at the intersection of Warren Road, Franklin Boulevard, and Hilliard Road in central Lakewood. In this photograph (c. 1925) the bridge is under construction. (CSU.)

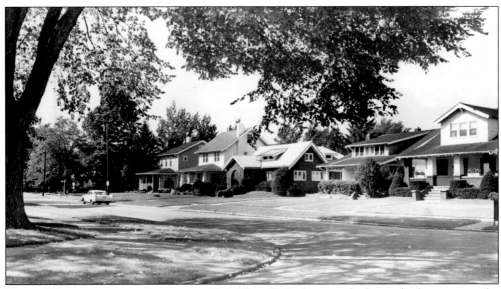

HOMES DEMOLISHED FOR INTERSTATE 90. This 1965 photograph shows the homes near the intersection of Delaware Avenue and Niagara Drive that were demolished for the construction of Interstate 90. At the time Delaware Avenue ran east-west from Brown Avenue to Riverside Drive. Following the construction of I-90, Delaware Avenue was re-routed to end at McKinley Avenue in the west. (CSU.)

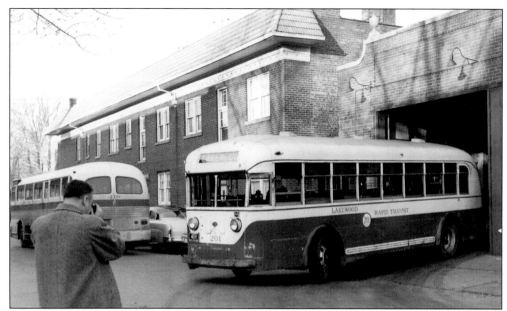

LAKEWOOD RAPID TRANSIT. Lakewood operated the Lakewood Rapid Transit, its own private bus company, until 1954 when it was bought by the Cleveland Transit System. Cleveland streetcar historian Harry Christiansen can be seen on left photographing LRT coach 201 leaving the garage at 2013 Atkins Avenue on the Lakewood Rapid Transit's last day of service. (CSU.)

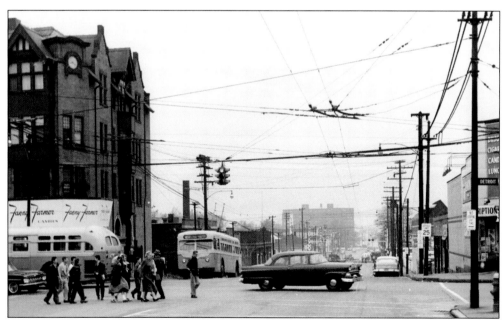

TRACKLESS TROLLEYS IN LAKEWOOD. At the intersection of Detroit Avenue and West 117th Street, in this c. 1950s photograph, a CTS bus crosses into Lakewood on Detroit Avenue while a southbound trackless trolley waits at the traffic light. The Fanny Farmer Candy store was located in the Hersch Block Building, which once stood on the northwest corner of Detroit and West 117th Street. (CSU.)

Four

LIBRARIES, SCHOOLS, AND CHURCHES

LAKEWOOD PUBLIC LIBRARY OPENS MAY 19, 1916. Mrs. C. Lee Graber and Mrs. Arthur B. Pyke, Board of Education members, obtained a $45,000 grant from the Andrew Carnegie Corporation in 1913 to build a library. Lakewood purchased the site at the southeast corner of Detroit and Arthur Avenues for $9,728, and construction began in 1915. Roena A. Ingham became head librarian and, with a budget of $10,000, purchased over 10,000 volumes to start the book collection. (LHS.)

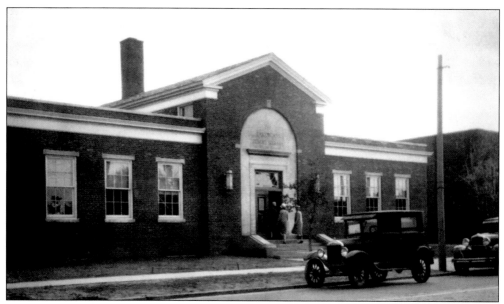

THE MADISON BRANCH LIBRARY OPENED IN 1929. To serve southeast Lakewood a temporary branch library opened in 1921. When Lakewood donated land in Madison Park the $47,000 one-story brick library designed by A.K. Murway was built. Florence Cottrell, the first librarian, supervised the initial purchase of 10,000 volumes including books in the Slovak language for residents of Bird Town. The library was remodeled in 1956. (LHS.)

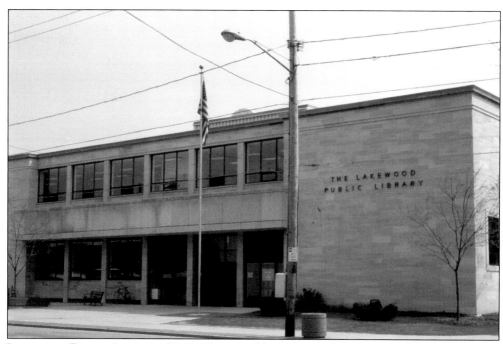

LAKEWOOD PUBLIC LIBRARY, 1981. The main library has undergone several facelifts. In 1958 the front of the building was removed and replaced with more windows creating an open look, and the main entrance was moved to the right. In 1981 steps leading up to the front door were replaced with a small concrete plaza and ground-level entrance. (LHS.)

EAST SCHOOL, C. 1871. The Ohio Common Schools Act of 1867 assigned Lakewood, then called Rockport, three one-room schoolhouses, Nos. 6, 8, and 10. In 1871 voters organized a separate school district called East Rockport with a three-member Board of Education. School No. 10 was renamed East School because it was located east of Warren Road, the town's center, on Detroit Avenue. (LHS.)

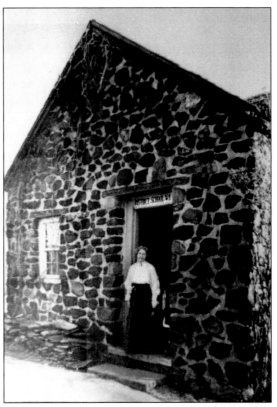

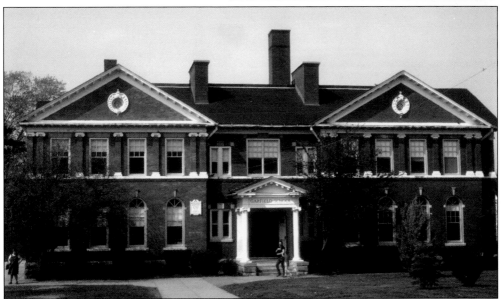

GARFIELD SCHOOL. In 1891 East School was divided into two rooms. In 1893 it was replaced by Garfield School, a four-room brick colonial designed by James Christford. The school board would name public grade or elementary schools for United States presidents, highlighting those from Ohio. Garfield was expanded to eight rooms in 1901 and then 16 rooms by 1911. It is located at 13114 Detroit Avenue. (LHS.)

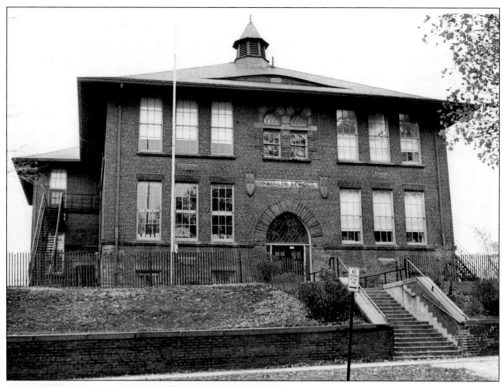

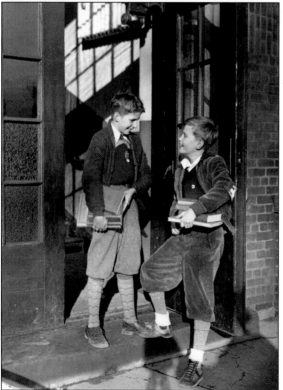

McKinley School. Located at 1351 West Clifton Boulevard, north of Detroit Avenue, McKinley was constructed on the former site of No. 8, West School. Built as a one-room schoolhouse in 1873, West was so-named as it was west of Warren Road. In 1899 a four-room building replaced the original school. Additions were completed in 1905, 1915, and 1921. In 1969 the west wing pictured here was replaced. (LHS.)

McKinley Schoolboys, 1933. Imagine boys walking to school nowadays wearing knickers and knee socks. Standing at the front entrance to McKinley are, from left to right, Ralph Jennings and Jack Engle modeling school fashions common for their day. Backpacks were unheard of at the time so textbooks were carried in arm or with a leather strap. (CSU.)

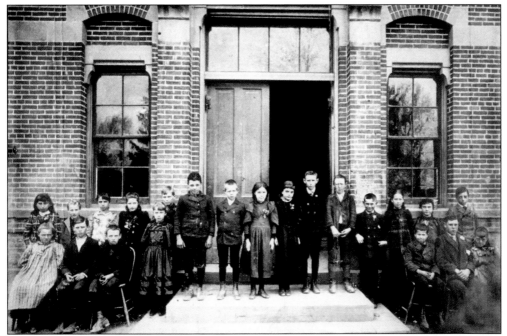

GRAMMAR SCHOOL CLASS OF 1893. Standing in front of East Rockport Central School are, from left to right: (standing) Edith Morgan, "unidentified," Fannie Mitchell, ? Trabeu, Bertha Parkin, Fred Buenk, David Wagar, Eben Brown, Florence Hobson, ? Parker, John Warner, Chris Oppliger, Fred Mitchell, Rita Ball, Mabel Bayes, and Maurice Hotchkiss; (seated) Gertrude Mullaly, Arthur Monahan, Robert Webb, Edwin Andrews, Charles Preslan, and "unidentified." (LHS.)

EAST ROCKPORT CENTRAL SCHOOL. The third original one-room schoolhouse was No. 6 or Middle School on Warren Road due south of Detroit Avenue. Like East and West Schools, Middle School was replaced with a four-room structure. Three rooms housed grammar or grade school classes, and one room was the high school. Now the Board of Education Annex, above the main entrance "East Rockport Central School, 1879" is still inscribed. (LHS.)

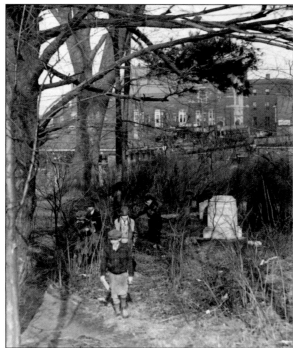

WAGAR CEMETERY SHORTCUT, 1930. Lakewood's only cemetery was once located between Belle and St. Charles Avenues on Detroit Avenue. Here it served as a convenient shortcut for these schoolboys attending either Grant or Wilson grade schools as they pass the monument of Joseph Hall of the prominent Hall family. (CSU.)

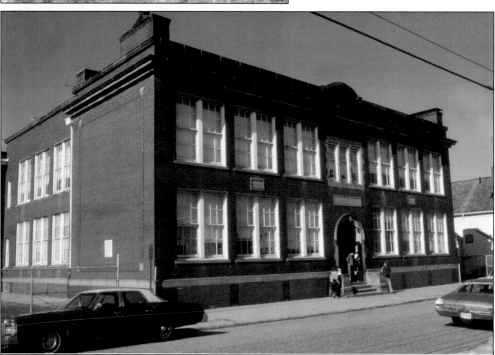

HARRISON SCHOOL. The development of Bird Town in southeast Lakewood led to the building of South School, a one-room schoolhouse. It was replaced in 1896 by Harrison, a two-room brick school at 2080 Quail Avenue. It was the first Lakewood school to offer Americanization classes for children of immigrants. Renovations over the years have increased the school's size to 21 classrooms and a gymnasium. (LHS.)

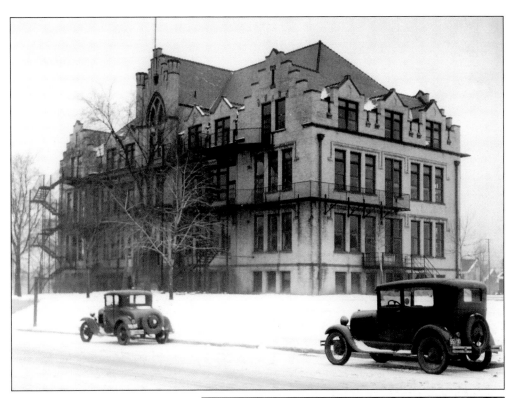

WILSON SCHOOL. In 1904 a high school was built on the east side of Warren Road. Called simply "the High School," this $72,000 three-story structure was the largest, most elaborate educational facility built in Lakewood. When Lakewood High School opened on Franklin Boulevard in 1919 the High School became Wilson Grade School. (CSU.)

WILSON SCHOOL, 1932. Wilson was used as an elementary school and a junior high school. In 1923 when the Lakewood Music School Settlement was formed it used Wilson to teach students piano and violin. When it ceased being used for educational purposes Wilson became a youth recreation hall, then a Red Cross center. Wilson was demolished in 1947. (CSU.)

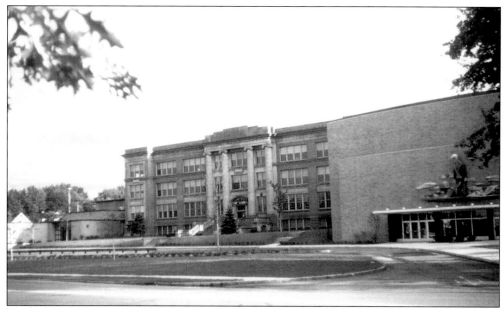

LAKEWOOD HIGH SCHOOL, 1953. Located at 14100 Franklin Boulevard Lakewood High opened in 1919. Charles W. Hopkinson designed the $1,125,000 campus on an 18-acre site to have a main building, men's building, women's building, and heating plant. At first the high school included six grades, three years of junior high and three years of high school until separate junior highs were built to handle student overflow. Lakewood Civic Auditorium is at the right, adjacent to the high school. (LHS.)

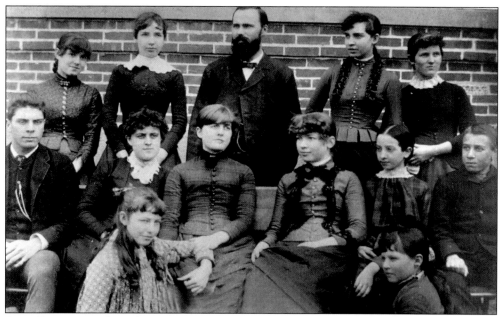

EAST ROCKPORT HIGH SCHOOL STUDENT BODY, 1883. From left to right are: (front row) Clara Thompson and Olive Bates; (second row) Arthur Oviatt, Ida Burgess, Rose Thorne, Elizabeth Sanderson, May Wagar, and Albert Hotchkiss; (back row) Mary Hutchins, Belle Tegardine, Professor W. L. Lippert, May Tegardine, and Nora Gleason. (LHS.)

FRANKLIN SCHOOL. Built in 1907 Franklin Elementary School, located at 13465 Franklin Avenue, was originally a four-room brick schoolhouse. Additional rooms were added in 1915 and 1921 to create a 12-room school. (LHS.)

MADISON SCHOOL. Built in 1912 Madison Elementary School, located at 16601 Madison Avenue, opened with 11 classrooms and underwent expansion in 1915 and 1916 to add eight additional classrooms. (LHS.)

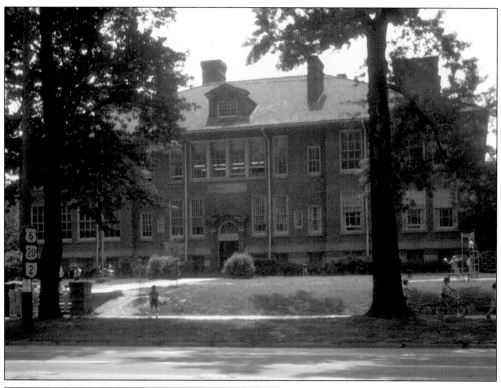

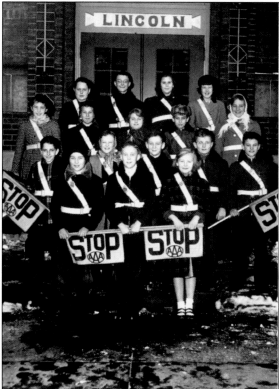

LINCOLN SCHOOL. Lincoln Elementary School, located at 15615 Clifton Boulevard in northern Lakewood, was built in 1913 when public school enrollment in Lakewood had reached an all-time high of 3,739. Additional classrooms were added in 1916 and 1920 making Lincoln the city's largest elementary school with 27 classrooms and two gymnasiums. Lincoln was designed by architect Charles W. Hopkinson. (LHS.)

LINCOLN SCHOOL CROSSING GUARDS. Fifth grade students pose in front of the main entrance wearing their safety belts and holding "STOP" flags as part of the Lakewood schools' program to promote safety in and around school buildings. (LHS.)

EMERSON JUNIOR HIGH SCHOOL. The first junior high school built in Lakewood was Emerson, located at 13439 Clifton Boulevard in northeast Lakewood. Designed by Charles W. Hopkinson, Emerson opened in February 1922 with 28 classrooms, a library, an auditorium, a gymnasium, and a cafeteria. The opening of Emerson brought an end to junior high classes being held at Lakewood High School. (LHS.)

HORACE MANN JUNIOR HIGH SCHOOL. The early 1920s saw Lakewood's population surpass 40,000, which put a tremendous demand on the school system to increase the number of schools. In September 1922, just seven months after Emerson opened, Horace Mann opened at 1215 West Clifton in northwestern Lakewood. It was another Charles W. Hopkinson design; actually its architectural twin. The two-story brick structure can accommodate some 350 students. (LHS.)

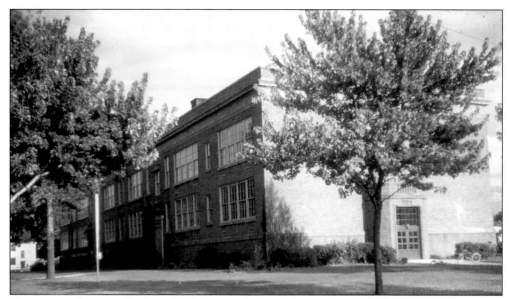

ROOSEVELT SCHOOL. Built in 1922 Roosevelt was Lakewood's ninth elementary school. It is located at 14237 Athens Avenue due south of Madison Avenue. A Charles W. Hopkinson design, it began as an eight-room structure and was enlarged to 24 classrooms by 1928. James W. Thomas designed later additions. The Madison Avenue streetcar line contributed to the development of the area, which meant more children in public school. (LHS.)

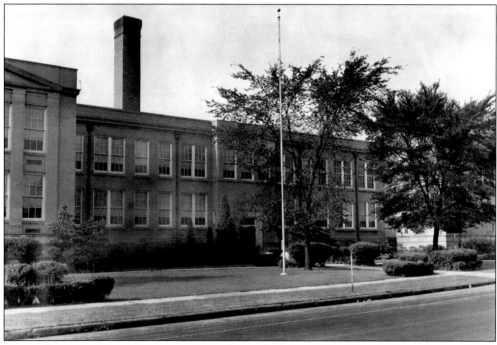

HAYES SCHOOL. Hayes Elementary School was built in 1925 when Lakewood's population surpassed 60,000. Located at 16401 Delaware Avenue south of Madison Avenue, it is Lakewood's southernmost public school. The original architect was Charles W. Hopkinson with later additions designed by James W. Thomas. Hayes has 25 classrooms and an auditorium. (LHS.)

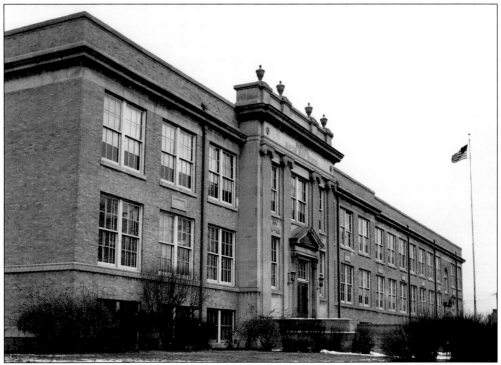

HARDING JUNIOR HIGH SCHOOL. The last and largest of Lakewood's junior high schools is Harding, designed by Charles W. Hopkinson. Built in 1925 at 16600 Hilliard Boulevard in southwestern Lakewood, Harding has 29 classrooms, a library, an auditorium, a gymnasium, and a cafeteria. A fourth junior high school, tentatively called Washington, was planned for construction north of Franklin Avenue and Bunts Road should the need arise. (CSU.)

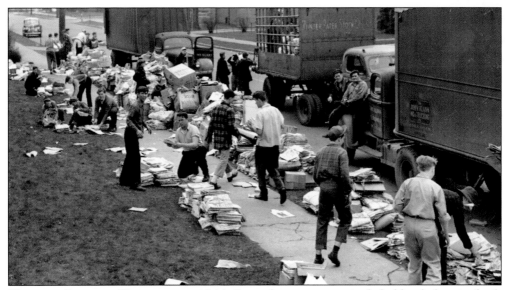

HARDING STUDENT VOLUNTEERS, 1944. Paper drives were routinely held to help raise funds for the World War II effort. Here Harding Junior High School students work to sort and load approximately 50 tons of cardboard and newspaper onto these trucks. (CSU.)

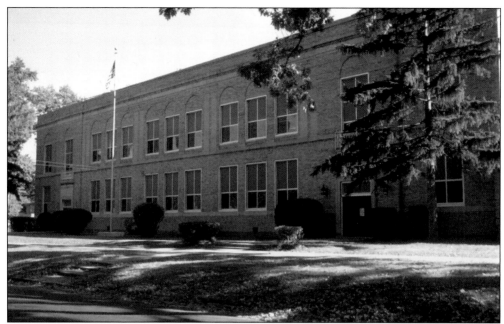

TAFT SCHOOL. Built in 1927 at 13701 Lake Avenue, Taft was the last elementary school in Lakewood designed by Charles W. Hopkinson. It is a modest two-story brick structure containing 13 classrooms, a library, a gymnasium, and an auditorium. Taft was built across the street from Emerson, which included elementary classes until Taft could be built to absorb the student overflow. (LHS.)

GRANT SCHOOL. This is Grant Elementary School in 1966, located on 1470 Victoria Avenue, which replaced the "old" Grant School seen in the right background with the domed-peak. The modern Grant was the last elementary school building constructed in Lakewood. The original Grant School, a two-story colonial structure, began as a high school built next to East Rockport Central School. When the new High School was built on the east side of Warren Road Grant became a grade school. (CSU.)

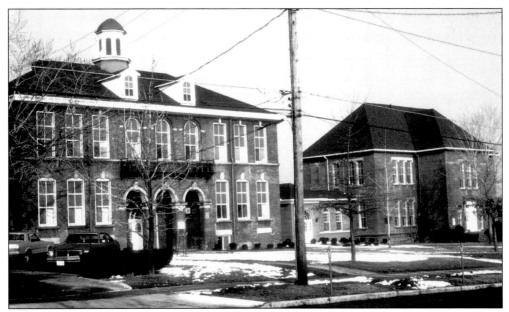

THE LAKEWOOD BOARD OF EDUCATION COMPLEX. Located on the west side of Warren Road, south of Detroit Avenue, is Lakewood's Board of Education and Recreation Department. As seen in this early 1980s photograph the building at right, the former East Rockport Central School is now the Annex and is connected to the building at left, the original Grant School and now the Board of Education building, by a small walkway. (LHS.)

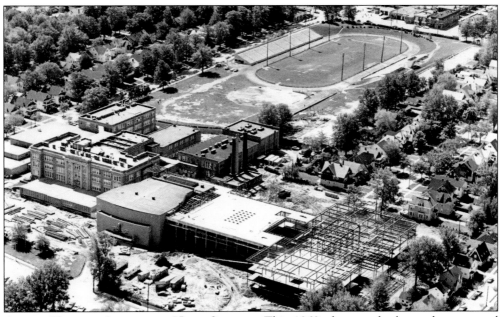

AERIAL VIEW OF LAKEWOOD HIGH SCHOOL. This 1969 photograph shows the westward expansion of Lakewood High School. The original high school building is at center left next to Bunts Road. The football stadium is at the top right just north of Madison Avenue. The street to the right of the construction area is Robinwood Avenue and at the bottom of the image is Franklin Boulevard. (CSU.)

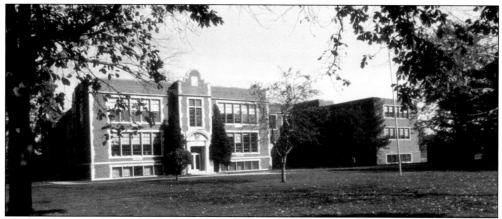

ST. AUGUSTINE ACADEMY, 1980. St. Augustine's is a Roman Catholic girls' high school founded in 1921 by the Sisters of Charity. It is located at 14808 Lake Avenue due west of Lakewood Park. In 1925 a new two-story brick with stone trim high school building designed by architect William Koehl was dedicated. In 1928 a second building, also a Koehl design, was dedicated as an elementary school. In time elementary instruction was eliminated and both buildings were used for high school classes. The sisters of the Holy Family presently run the school. (LHS.)

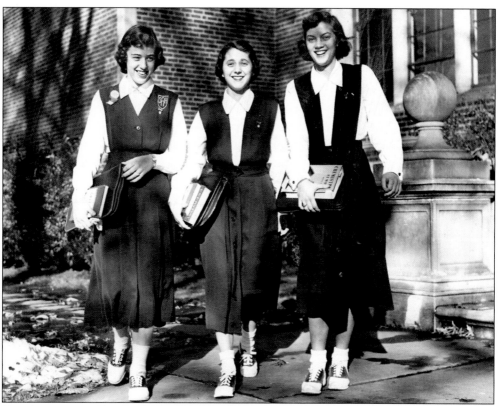

ST. AUGUSTINE STUDENTS, 1951. Strolling across St. Augustine's campus on a warm November day are, from left to right, students Mary Schwind, Mary Ann Warnement, and Margy Kovach, wearing the traditional jumper uniforms, bobby socks and saddle shoes, and winning smiles. (CSU.)

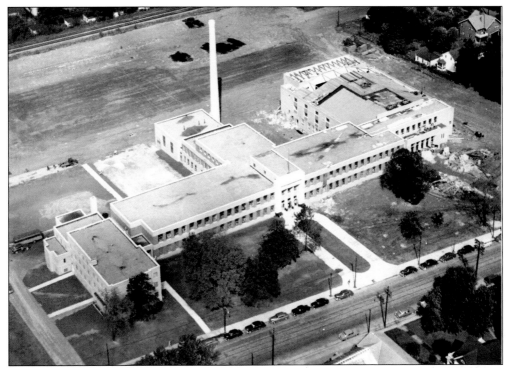

ST. EDWARD HIGH SCHOOL, 1951. Located at 13500 Detroit Avenue, St. Edward High School was founded in 1949 by the Brothers of Holy Cross of Notre Dame, Indiana. The Roman Catholic boys' school held its first classes at 14205 Detroit Avenue in a building formally used by St. Theresa's Academy, a girls' high school that has since closed. St. Edward's moved into its new building in 1951. (CSU.)

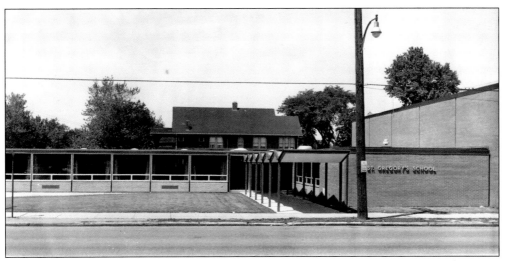

ST. GREGORY'S SCHOOL. St. Gregory's parochial school and recreation center opened in 1962 at Madison and Cohassett Avenues in the heart of Bird Town. The $250,000 educational facility was part of St. Gregory the Theologian Byzantine Catholic Church at 2035 Quail Avenue that was established in 1905 to serve the Eastern Orthodox Carpatho-Russian community. The school is staffed by the Sisters of Christ the Teacher. (CSU.)

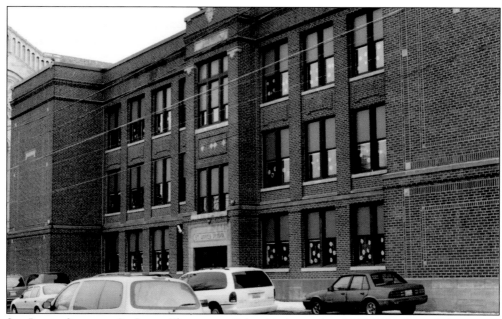

ST. JAMES SCHOOL. St. James Elementary School is located at 17415 Northwood Avenue in western Lakewood. The Roman Catholic school opened for instruction in 1912 and is affiliated with St. James Catholic Church located on the northwest corner of Detroit and Granger Avenues. St. James School is a simple three-story brick building that stands in contrast to the elaborate church. St. James belongs to the Catholic Diocese of Cleveland. (LHS.)

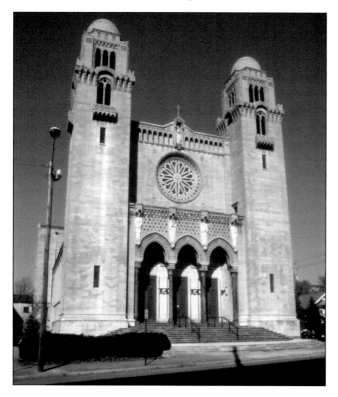

ST. JAMES ROMAN CATHOLIC CHURCH. St. James was founded in 1908 and is located at 17514 Detroit Avenue. It was the first Catholic congregation in Lakewood formed outside the Bird Town district. As membership increased a new church was dedicated on May 12, 1935. St. James cost over $550,000 to complete and remains one of the area's finest examples of the Sicilian Romanesque architectural style. (CSU.)

CONSTRUCTION OF ST. PAUL LUTHERAN CHURCH. St. Paul Lutheran Church of Lakewood is located due west of the Lakewood Public Library, which can be seen in the middle background of this photograph. Here the foundation is being readied for the church to be built on the southwest corner of Detroit and Arthur Avenues. The builders appear to be taking a break while the horses graze on the grounds. (LHS.)

ST. PAUL LUTHERAN CHURCH. St. Paul Lutheran School of Lakewood, foreground right, is located at 1419 Lakeland Avenue. The elementary school is part of St. Paul Lutheran Church on Detroit and Arthur Avenues, seen in background at left. When the school first opened classes were held in a building next to the church. In 1978 the Lakewood Lutheran School Association built the new $750,000 elementary school. (CSU.)

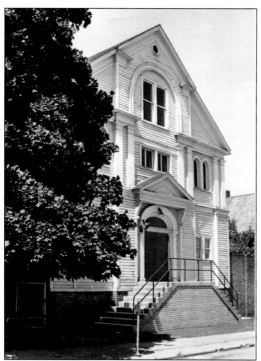

SS. CYRIL & METHODIUS ROMAN CATHOLIC CHURCH AND SCHOOL. SS. Cyril & Methodius Church was founded *c.* 1902 at 12608 Madison Avenue to serve the Roman Catholic Slovak community of Bird Town. The original frame church, pictured here, was replaced by a stone structure dedicated in 1949. In 1908 an elementary school was opened at 1639 Alameda Avenue and run by the Sisters of Notre Dame. (CSU.)

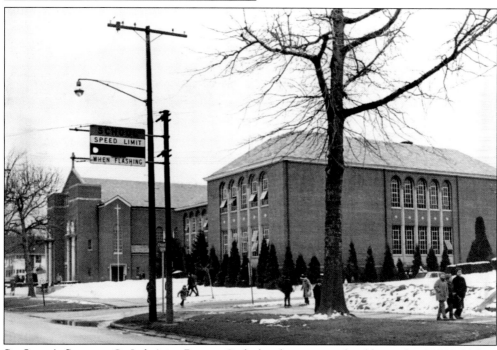

ST. LUKE'S SCHOOL. St. Luke's is a Roman Catholic elementary school located at 13889 Clifton Boulevard and is annexed to St. Luke's church and parish. St. Luke's Church, seen at left, is at 1212 Bunts Road on the southwest corner of Clifton Boulevard. St. Luke's school, seen at right, was designed by William Koehl and opened for instruction in 1922. It is part of the Catholic Diocese of Cleveland. (CSU.)

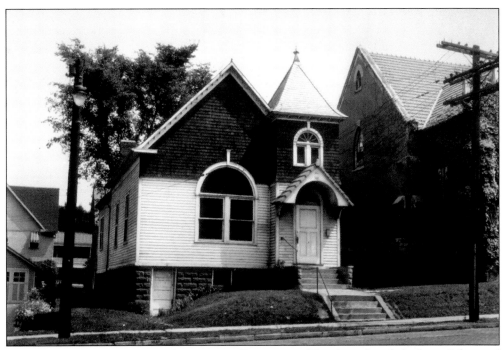

THE FIRST NEW JERUSALEM CHURCH OF ROCKPORT. The first church built in Lakewood occurred during the Rockport Township era. It was located on Detroit Avenue and called the *Swedenborgian Church* or The First New Jerusalem Church. Early pioneer James Nicholson organized the church in 1841 based on the writings of Emmanual Swedenborg, a teacher and scientist. This historic structure was razed in 1971 to make room for another church. (LHS.)

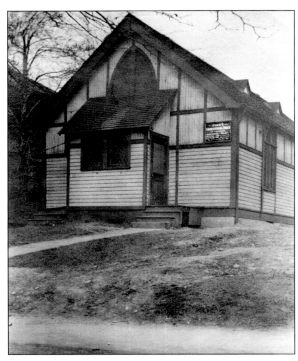

FIRST CONGREGATIONAL CHURCH OF LAKEWOOD. The First Lakewood Congregational church is located on West Clifton and Detroit Avenue. The congregation was organized on December 8, 1905. Seen here is the first church built on November 29, 1906. The building was a simple colonial in design and featured a portable chapel. On November 12, 1916 a new church was dedicated. In 1953 the congregation changed its name to Lakewood Congregational Church. (CSU.)

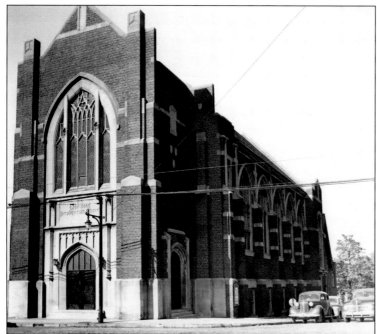

LAKEWOOD PRESBYTERIAN CHURCH. Located at Detroit and Marlowe Avenues, the Presbyterian congregation was organized on March 12, 1905 as a branch of the Old Stone Church located on Public Square in Cleveland. Church members met in a tent, then a home, and a hall until the congregation built a small chapel in 1908. The present church was dedicated on March 17, 1918. (CSU.)

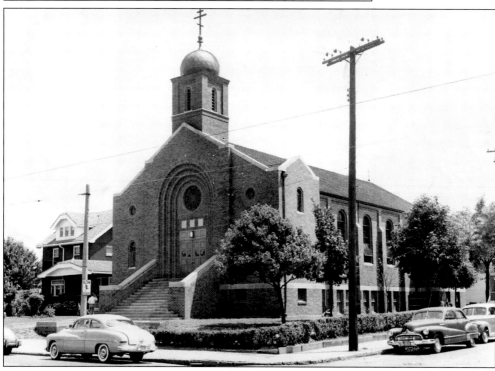

SS. PETER & PAUL ORTHODOX CHURCH. Located on 12711 Madison Avenue in Bird Town in southeastern Lakewood, the congregation was founded on July 19, 1917 by the Carpatho Russian Eastern Orthodox group. The first church built by the congregants was a wooden frame structure located on Quail Avenue. The present church seen here was built in 1950 and has the onion-shaped dome characteristic of the orthodox faith. (CSU.)

Five

CLIFTON PARK

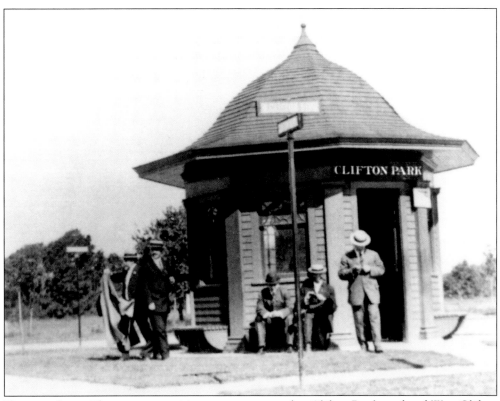

TROLLEY STOP. This streetcar waiting room once stood at Clifton Boulevard and West Clifton at the east entrance to Clifton Park. The Clifton Park Lakefront District is an exclusive residential area of expensive and stately homes located in the northwest corner of Lakewood near the Rocky River Valley, bordered by Clifton Boulevard and Webb Road. This unique octagonal-shaped trolley stop featured six windows with bench seating and two doors. (LHS.)

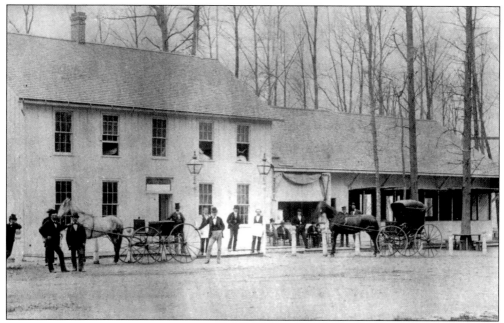

LAKE VIEW HOUSE. Clifton Park was first developed as a summer resort area. In 1866 several wealthy businessmen and real estate developers including Ezra Nicholson, son of Lakewood pioneer James Nicholson, saw great potential for the area. The Clifton Park Association was then formed to attract Clevelanders seeking recreation and entertainment. Lake View House was a hotel in Rockport Township when the area became part of Clifton Park. (LHS.)

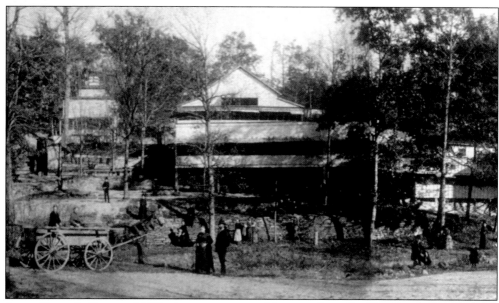

JOHN KNOLL'S PLACE, 1887. A resort area and beer garden, Knoll's Place was located in Clifton Park at the base of the Rocky River. Popular during the 1870s and 1880s, Knoll's Place featured beautiful picnic grounds, boating and swimming activities, and even a dance hall. The Rocky River Railroad, known also as the Dinky or Dummy Railroad, carried visitors who passed on wagon parties to reach the resort. (LHS.)

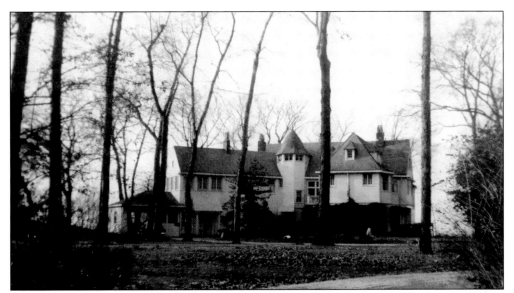

WYWOKA, THE STARKWEATHER ESTATE. The first residence built in Clifton Park *c.* 1894 was *Wywoka* located at 17866 Lake Road. It was a summer retreat for William Starkweather, attorney and real estate developer, and his wife Leafie. Wywoka featured a tower, 19 large rooms, a mahogany interior, and seven fireplaces. Starkweather helped develop Clifton Park into an exclusive residential community. In 1969 *Wywoka* was razed for the Lake Point Drive subdivision. (CSU.)

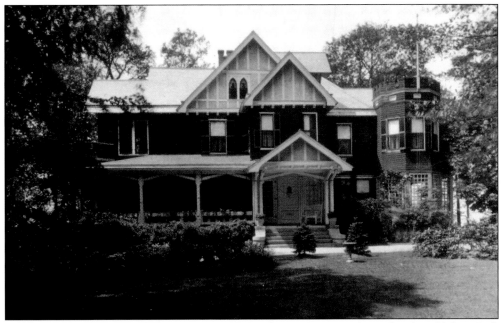

RESTCLIFF, THE JENNINGS' ESTATE. In 1894 80 lots were set aside to develop Clifton Park into a residential area. Built *c.* 1899, the John G. Jennings estate at 17862 Lake Road was the third residence built here. Jennings, a wealthy businessman, built *Restcliff* with spacious rooms, large fireplaces, and a spectacular lake view. After *Wywoka* was demolished *Restcliff* remains the oldest residence in Clifton Park. (LHS.)

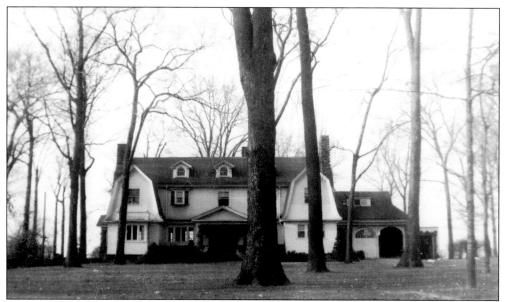

CLIFTON PARK ESTATE, 17864 LAKE ROAD. In 1899 the Clifton Park Association sold its holdings to the Clifton Park Land Improvement Company. The privacy Clifton Park offered with its tall trees and winding streets set against the backdrop of Lake Erie created a mini-housing boom encouraged by the company. This three-story home, photographed here in 1944, was built c. 1905 with seven dormers, three bay windows, and rich woodwork. (CSU.)

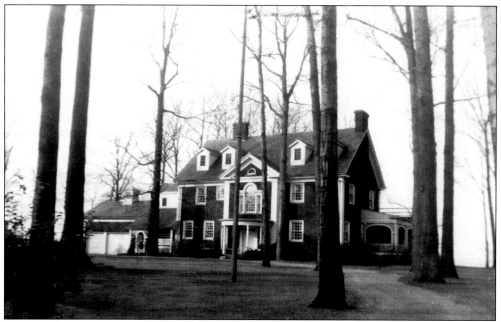

CLIFTON PARK ESTATE, 17856 LAKE ROAD. This estate built in 1906 was representative of the baronial manor homes defining the Clifton Park Lakefront District. As seen in this 1944 photograph the lakefront mansion was separated from the main road by numerous trees in order to give it the secluded effect desired by the area's wealthy property owners. Among its lavish features were eight dormers, two bay windows, and a gabled roof. (CSU.)

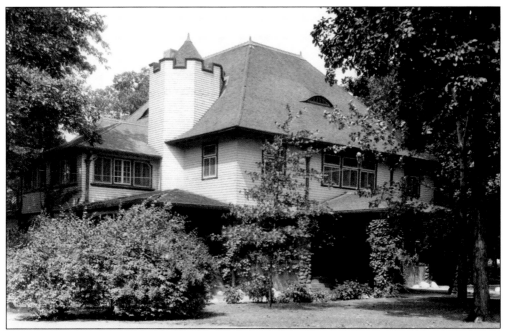

THE CLIFTON CLUB, 1931. As Clifton Park developed into an exclusive community, a private social life, limited to area families, was built around the Clifton Club, which opened in 1904 at 17884 Lake Road. Membership in the club, as well as access to the private beach and lagoon, required nothing more than Clifton Park residency. The club hosted a variety of social events with an A-list of attendees. (CSU.)

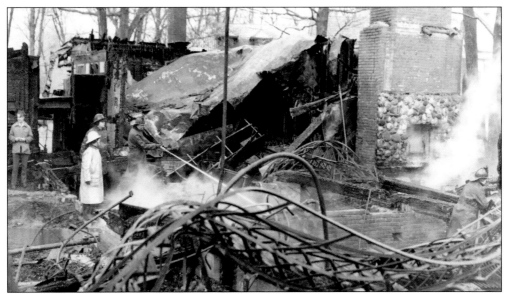

THE CLIFTON CLUB FIRE. During the morning hours of January 11, 1942 the original Clifton Club located near the Rocky River Valley was completely gutted by fire. Here firemen work to contain the flames smoldering amid the tangled metal and concrete rubble. Damage was assessed at $75,000. It would be eight years, 1950, before a new Clifton Club was built on the same site. (CSU.)

"CLIFTON PARK IS NOT FOR EVERYONE." The message on this sign seen here in 1961 blocking the entrance to the roadway leading down into Clifton Park Beach and Lagoon is quite clear—members and their invited guests only. (CSU.)

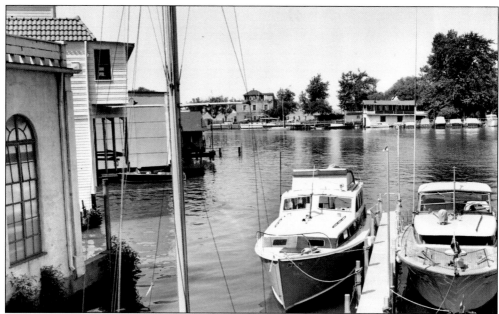

CLIFTON PARK LAGOON AND MARINA, 1961. Clifton Park's proximity to the Rocky River and the Rocky River Valley has always attracted visitors who enjoyed water activities and sandy beaches. Around 1912 the lagoon was dredged to create water lots, which were sold to members interested in boating and yachting. Boat houses were built a few years later for year-round enjoyment. (CSU.)

LEAPFROG ON CLIFTON BEACH. Here in this 1943 photograph are five young ladies enjoying a game of leapfrog on the sandy beach. They are, from left to right, Shirley Reese (in mid-jump) Peggy Proctor, Joy Miller, Joyce Cooke, and Martha Clark. Access to the beach was reserved for residents and invited guests. (CSU.)

CLIFTON BEACH AND LAGOON RESIDENCES, 1977. Standing close together like town houses is this row of residences located on Beach Road. Each house is unique in design and is situated near the lagoon for easy access to boats. The houses range in size from one to three stories with open porches upstairs and parking in front. Some remain summer homes while others have become permanent residences. (CSU.)

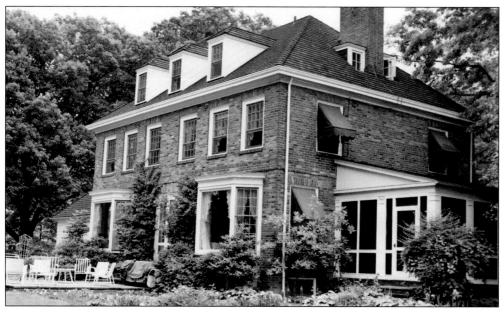

STOUFFER'S CLIFTON PARK ESTATE, 1951. This is the colonial-style home of Vernon Stouffer and his wife Gertrude, located at 17884 Beach Road and purchased by the couple in 1947. The house and grounds is shrouded in trees and greenery to create a peaceful, pastoral effect. Like many successful businessmen, Vernon Stouffer, president of Stouffer Foods Corporation, which began in Cleveland, was attracted to the privacy offered by Clifton Park. (CSU.)

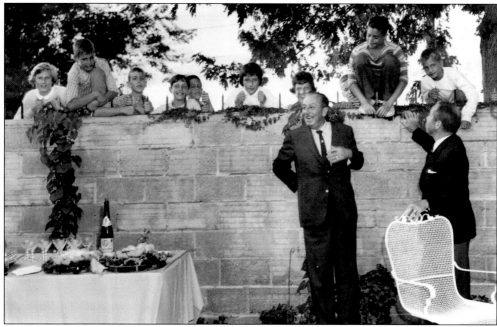

STOUFFER ENTERTAINS DISNEY AND COMPANY, 1961. It was not unusual for residents of Clifton Park to be not only well-to-do, but well-connected. Here Vernon Stouffer, at right with hand on wall, plays host to his friend Walt Disney, standing at left, before a row of enthusiastic children. (CSU.)

THE LOUIS B. SELTZER ESTATE, 1951. The home of Louis B. Seltzer, 38 year editor of *The Cleveland Press* daily newspaper and recognized as one of the country's leading editors, is located at 17825 Lake Road in Clifton Park. Seltzer and his wife, Marion, purchased the home in 1936 and remained for 30 years. The heavily wooded yard appealed to the secluded feeling Clifton Park residents desired. (CSU.)

SELTZER GARDENS. When Lakewood first identified itself as a city of beautiful homes and gardens the area of Clifton Park came specifically to mind. Mr. and Mrs. Seltzer created impressive gardens, which were featured in the Lakewood Garden Tours as representative of some of the best in the area. The gardens seen here in this 1951 photograph were designed for the Seltzer grandchildren when they came to play in the backyard. (CSU.)

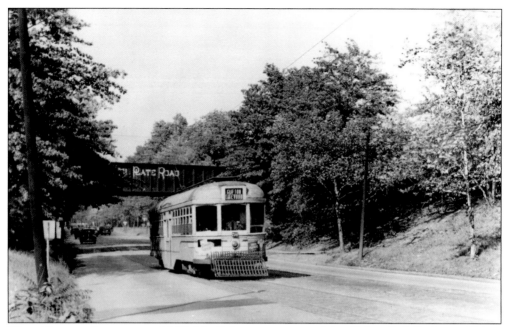

WEST CLIFTON BOULEVARD, 1940. Until the construction of the Clifton Park Bridge in Clifton Park, access from Lakewood to Rocky River occurred via West Clifton. Named for John M. West, a large landowner, and his grandson, Clifton, West Clifton runs north-south between Clifton Boulevard and Riverside Drive in western Lakewood. Here a streetcar passes under the Nickel Plate Railway Bridge heading south towards Sloane Avenue on its way to Rocky River. (Bruce Young.)

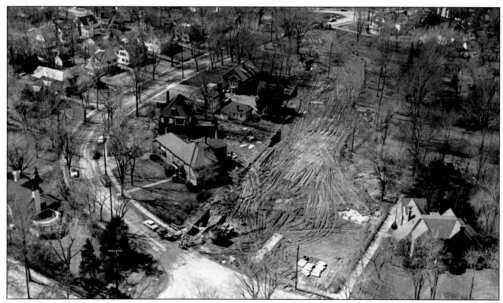

CLIFTON PARK BRIDGE CONSTRUCTION, 1963. This aerial view of Clifton Park shows the area cleared to make way for the path or approach leading to the new bridge. Eight homes and 15 other parcels of land were affected by the right of way. West Clifton Boulevard is at the bottom left intersected by Clifton Boulevard, which ends at the start of the path marked by heavy vehicle tracks. (CSU.)

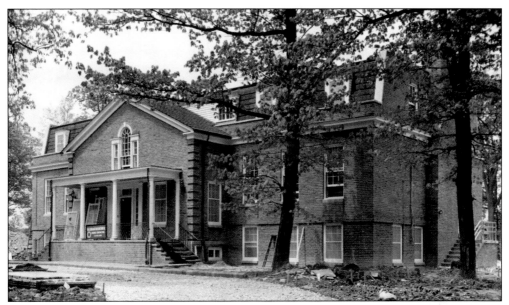

THE CLIFTON CLUB, 1950. Eight years after the original Clifton Club was destroyed by fire in 1942, a new social club was built on the same site. It is located due north of the Clifton-Rocky River Bridge approach. As seen here the finishing touches are being applied as screens rest on the porch and the drive readied for landscaping. This club was built by The Cleveland Construction Company. (CSU.)

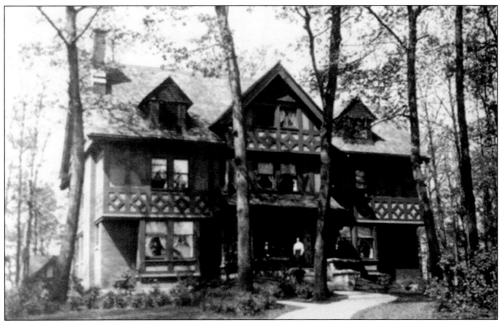

RIVERBANK, THE REED ESTATE. In order to make room for the Clifton Park Bridge approach, about 15 homes were either moved or demolished. Here is a photograph of the estate of Lyman A. Reed called *Riverbank*, which was located at 17894 Lake Road. Reed was an executive with the Diamond Portland Cement Company. His stately home was one of those razed for the bridge approach construction. (CSU.)

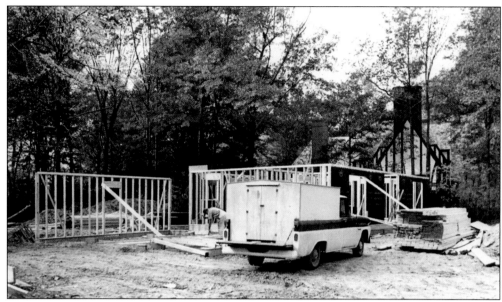

CONSTRUCTION RESUMES IN CLIFTON PARK, 1964. This is a photograph of the first new home under construction in Clifton Park after the building of the Clifton-Rocky River Bridge and approach was underway. The home is being built at 18094 Clifton Road for Ellie Wallner at an estimated cost of $60,000. According to the Lakewood building department, there were still two or three lots available in Clifton Park for new homes. (CSU.)

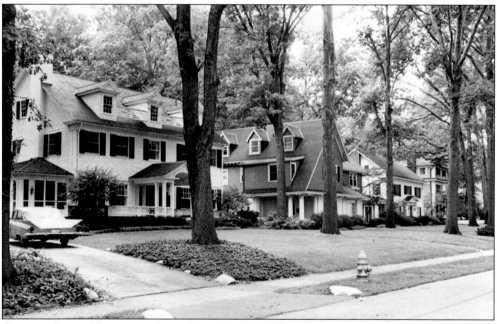

CLIFTON PARK HOMES ON LAKE ROAD, 1969. The Clifton Park Lakefront District was placed on the National Register of Historic Places in 1974 because the area boasts a distinctive architectural style in individual residences and overall community development. The homes pictured here on Lake Road are representative of multi-story residences, achieving privacy with large front yards set back from the main road and dotted with towering trees. (CSU.)

Six

THE GOLD COAST

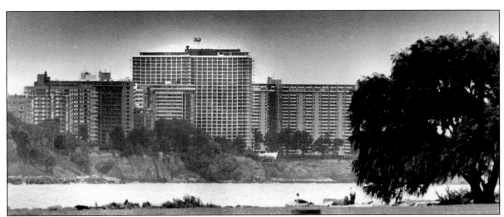

THE "GOLD COAST" FROM EDGEWATER PARK, 1981. This is Lakewood's Gold Coast as seen from across Lake Erie in a skyline view from Edgewater Park. The Gold Coast refers to a series of swank high rise apartment buildings erected parallel to Lakewood's northeast lakefront. The tallest high rise apartment in the center is Winton Place with the signature "W" on the rooftop. Winton Place opened in 1963 and, at a cost of $20 million, was the most expensive luxury apartment built in Lakewood. At 27 stories it was the tallest high-rise between New York and Chicago. (CSU.)

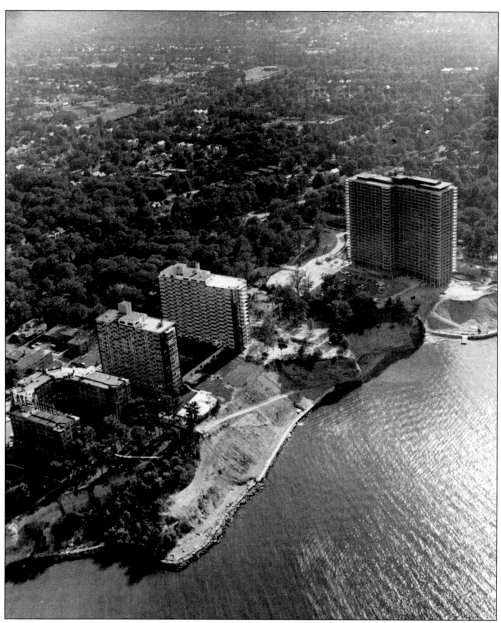

AERIAL VIEW OF THE GOLD COAST, 1964. This spectacular view over Lake Erie looks south along the Gold Coast to show, from left to right, the horseshoe-shaped Lake Shore Hotel, Marine Towers east, Marine Towers west, and Winton Place. The idea for the Gold Coast arose in the 1950s when Lakewood had developed all available land leaving only one way to build—upwards. "Operation Lakewood" was the name given the program that would give the city its next building boom. Baronial estates that once dotted the shoreline would be demolished and replaced with expensive apartment complexes covering 35 acres and extending 2,000 feet along the Lake Erie coast. There were eight natural gas wells still working in the area, which increased the Gold Coast's value and appeal. When construction began, the amount in building permits issued was $1.9 million. In 1961 the amount in building permits issued topped $19 million. Lakewood had struck gold! (CSU.)

THE LAKE SHORE HOTEL. The Lake Shore Hotel, now Lake Shore Towers, located at 12506 Edgewater Drive, was the first high rise building erected in Lakewood. The Lake Shore opened as a 450-suite luxury hotel in 1929 and quickly attracted not only wealthy Clevelanders and suburbanites, but celebrities nationwide. The large electric red sign that once graced the hotel's roof was the largest sign of its kind between New York and Chicago. (CSU.)

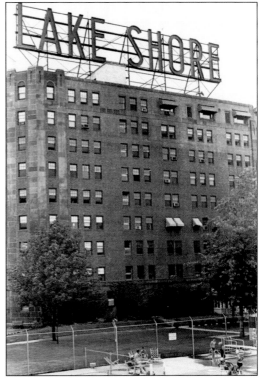

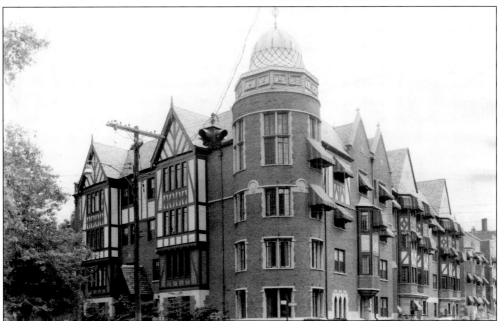

EDGEWATER COVE APARTMENTS. Across the street from Lake Shore Towers on Edgewater Drive is this 25-suite apartment complex originally called Edgewater Cove. The name was reminiscent of an area that once existed nearby called Cove Beach, a popular bathing site in the late 1890s. The brick apartments were built in an English Tudor architectural style and, when photographed here in 1954, valued at $300,000. (CSU.)

THE BERKSHIRE, 1958. This simple in design, yet imposing building opened in the mid-1950s as an apartment at 11820 Edgewater Drive. It stands on the site of the former Paisley Estate, which occupied three acres north of Lake Avenue along West 117th Street to Lake Erie. When the condominium craze took hold beginning in the 1960s, the 10-floor, 220-suite Berkshire Apartments became the Berkshire Condominiums. (CSU.)

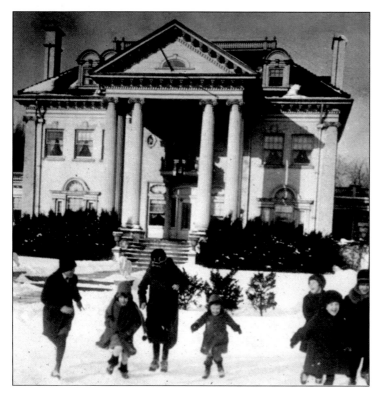

THE PAISLEY ESTATE, 1923. Built in 1907 on Edgewater Drive near West 117th Street, the estate of James A. Paisley is but one example of the beautiful homes razed for the Gold Coast. Paisley was a wealthy businessman whose family is seen here in front of the main house, which had among its many luxuries a third-floor ballroom and an elevator. The house was demolished in 1952. (LHS.)

THE PAISLEY ESTATE REMNANT. The original Paisley estate included the main house plus an additional four buildings on three acres of land. All but the barn was razed for the Berkshire. Seen here is the former barn, which was converted into a private residence on Edgewater Drive. The silo to the right of the structure was remade into a spiral staircase, and the entire barn remodeled as a duplex. (LHS.)

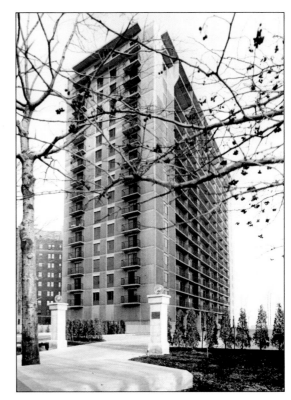

THE WATERFORD, 1975. The Waterford condominium complex is located at 12500 Edgewater Drive, which is the northernmost street running east-west in Lakewood. The Waterford, with 125 apartments covering 16 floors, stands as an elegant example of the kind of luxury high rise dotting the lakefront. (CSU.)

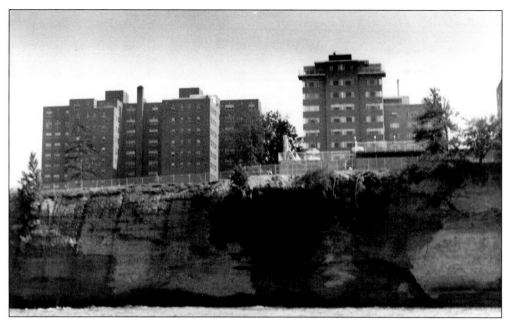

EDGEWATER TOWERS AND THE SHOREHAM, 1961. Edgewater Towers Condominiums is seen at left, and the Shoreham Apartments is at right on Edgewater Drive as viewed from the lake. Edgewater Towers opened in 1951and ushered in the building boom along the Gold Coast. The Shoreham was built on the site of the former estate of artist M. Louise Obermiller. (CSU.)

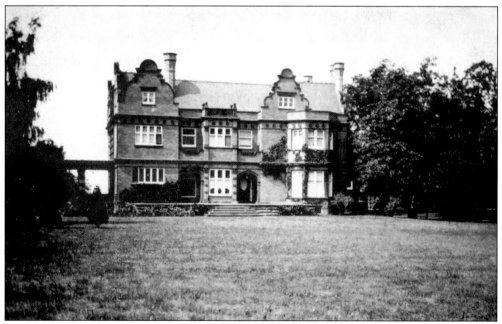

THE OBERMILLER ESTATE. The home of M. Louise Obermiller as seen here once stood at 11800 Lake Avenue. This magnificent home was razed to make room for the Shoreham Apartments at 11800 Edgewater Drive. The reason the Shoreham bears an Edgewater address rather than Lake Avenue is that when Edgewater Drive was first constructed in 1918 properties bearing a Lake Avenue address were changed to Edgewater. (LHS.)

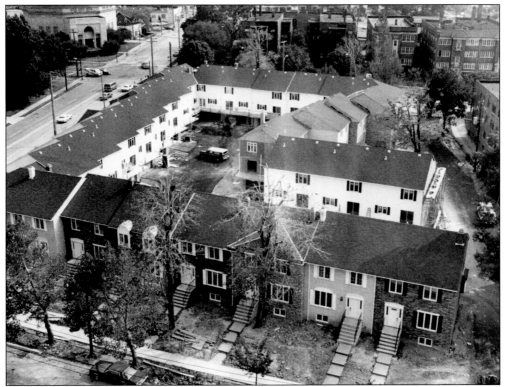

EDGEWATER SQUARE CONDOMINIUMS, 1979. This is an aerial view of the Edgewater Square Condominium complex on Edgewater Drive under construction. Edgewater Drive is located at the bottom of the photograph. Towards the upper left is West 117th Street or Highland Avenue, which borders Cleveland in northeastern Lakewood. Condominiums and townhouses would continue the building boom in Lakewood. (CSU.)

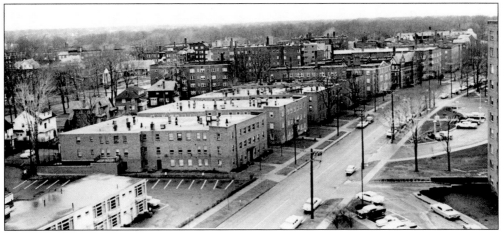

EDGEWATER DRIVE, 1961. When Edgewater Drive was cut through in 1918 beautiful mansions and summer homes were built lakeside. Looking west down the south side of Edgewater, the apartments replacing them line the street. Edgewater is split into four sections: moving east to west there is West 117th Street to Cove Avenue; Nicholson Avenue to Lakewood Park; St. Augustine Academy to Summit Avenue; and Kenneth Drive to Webb Road. (CSU.)

LAKE AVENUE ESTATES, 1969. All along Lake Avenue, which runs parallel to Edgewater Drive, mansions were demolished to make room for high rise buildings on the Gold Coast. Here on the north side of Lake Avenue on the 12600 block, separated from the road by a low-lying brick wall, are some of the homes that remain between Winton Place and Marine Towers Apartments. (CSU.)

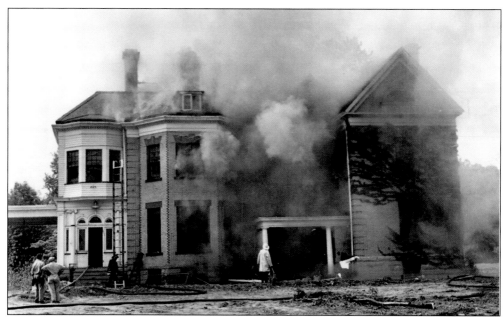

THE WINSTON ESTATE UP IN FLAMES. One of the more spectacular Lake Avenue homes destined to meet the wrecking ball was *Roseneath*, the estate of automobile pioneer Alexander Winton. Winton's 25-room mansion was located at 12906 Lake Avenue on the present site of Winton Place at 12700 Lake Avenue. When no longer used as a mansion *Roseneath* was to become a rooming house when fire destroyed it in 1962. (CSU.)

MANSION *FREE* FOR THE TAKING, 1969. Dr. Robert Stecher and family lived in this home at 12962 Lake Road for 40 years. When Gold Coast developers marked this Georgian-style mansion built in 1918 for destruction, it was offered for free to anyone willing to pay approximately $25,000 to have it moved. There were no takers, and the house was demolished for an underground parking garage for the Carlyle. (CSU.)

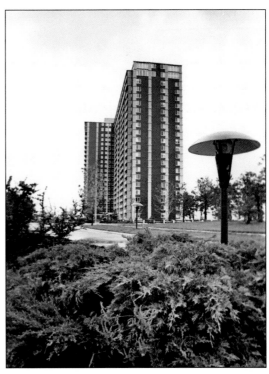

THE CARLYLE, 1972. The Carlyle is an $11.5 million, 20-story condominium located at 12900 Lake Avenue right next door to Winton Place. The Carlyle occupies the site of *Adar*, the former home of Frederick W. Stecher, father of Dr. Robert Stecher. Frederick Stecher's spacious *Adar* was located at 12960 Lake Avenue next to his son's home. Frederick Stecher was president of the Pompeian Manufacturing Company, which made toiletries. (CSU.)

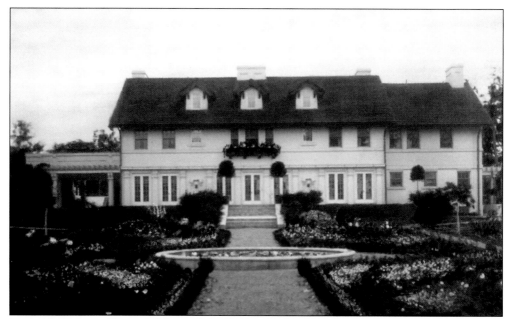

THE ZIMMERMAN ESTATE. Many of the Edgewater Drive and Lake Avenue estates razed for the Gold Coast had spectacular gardens extending down to the shoreline. Still standing at 13514 Edgewater, formerly Lake Avenue, is this estate once owned by Frederick Zimmerman of the Zimmerman Company, picture frame makers. Taken in the early 1920s this photograph displays the beauty and desirability of lakefront property. (LHS.)

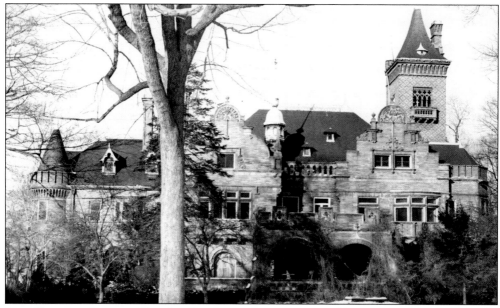

THE KUNDTZ CASTLE. Theodor Kundtz was an immigrant Hungarian cabinetmaker who made a fortune as a manufacturer of sewing machine cabinets for the White Sewing Machine Company on Berea Road. Kundtz built his mansion at 13826 Edgewater, formerly Lake Avenue, based on the design of a real castle in Hungary. It featured a five-story tower. In 1961 the estate was razed to make room for the Kirtland Lane development. (CSU.)

Seven

ENTERTAINMENT AND RECREATION

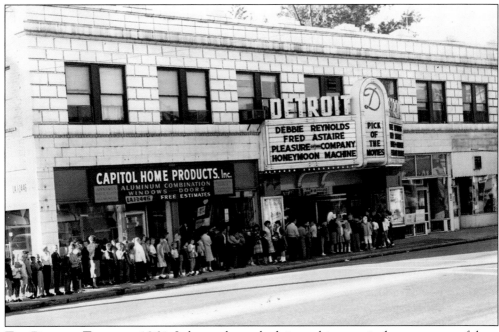

THE DETROIT THEATER, 1961. Lakewood once had six working movie theaters, many of them on Detroit Avenue. The Detroit Theater, 16409 Detroit Avenue, opened in 1924 and remains the only movie theater in town. Here patrons line up to see Debbie Reynolds and Fred Astaire in *The Pleasure of His Company*. The second feature, *The Honeymoon Machine*, starred a young Steve McQueen. (CSU.)

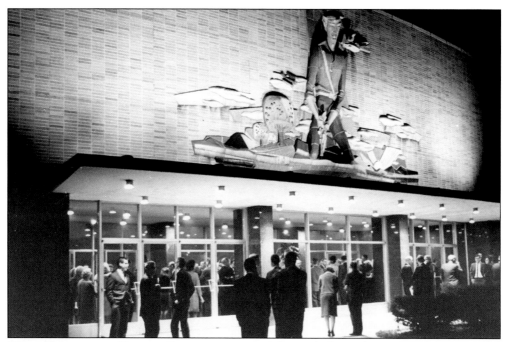

EARLY SETTLER BY VIKTOR SCHRECKENGOST. Mounted above the main entrance to the Lakewood Civic Auditorium is the terra cotta sculpture titled *Early Settler* by renowned artist Schreckengost. This work won first prize at the Third Architectural Ceramic Sculpture Competition held in 1954 at the Syracuse Museum of Fine Arts. The original title, *Johnny Appleseed,* was changed by the Board of Education since the Ohio folk hero was not a Lakewoodite. (CSU.)

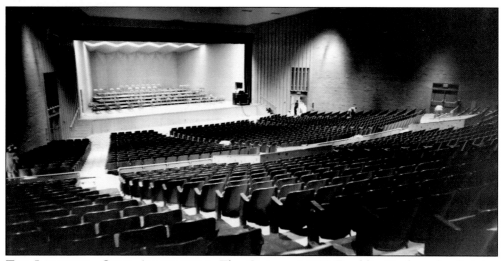

THE LAKEWOOD CIVIC AUDITORIUM. The Civic at 14100 Franklin Boulevard, adjoining Lakewood High School, was the City's "crown jewel." The $1.2 million auditorium was built by the Board of Education and designed by Cleveland architects Hays & Ruth. The 1,800-seat Civic hosts events sponsored by Lakewood public schools and various community organizations. The Civic opened in April 1955 with the Cleveland Orchestra and guest conductor Robert Shaw. (CSU.)

116

THE GREAT LAKES SHAKESPEARE FESTIVAL. The Great Lakes Shakespeare Festival opened as a summer repertory theater in July 1962. Productions were staged at the Lakewood Civic Auditorium at Lakewood High School. This municipal sign on Lake Avenue at West 117th Street highlighted both GLSF and Lakewood's commitment to the cultural arts. In 1982 the GLSF moved to Playhouse Square in downtown Cleveland and became the Great Lakes Theater Festival. (CSU.)

BACKSTAGE AT THE GLSF, 1978. Aspiring actors were given many opportunities to develop their skills both on stage and behind the scenes. Here a pair of interns, Tom Hanks (left) and Bert Goldstein are busy working on the production set off stage. (CSU.)

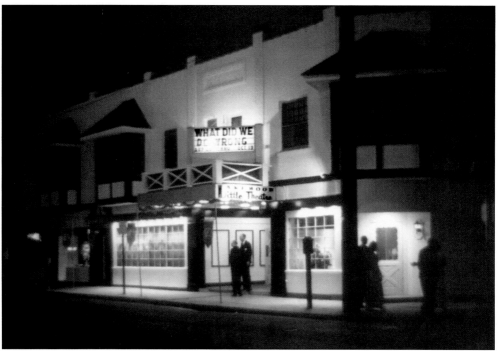

THE LAKEWOOD LITTLE THEATER. The Guild of the Masques theater group roamed Lakewood giving performances at clubs, schools, churches, and meeting rooms. In 1933 the Guild changed its name to Lakewood Little Theater, and in 1938 LLT rented the Lucier Theater, an old movie house at 17823 Detroit Avenue. In 1943 LLT purchased the entire Lucier theater block. LLT moved into the Beck Center in 1976. (LHS.)

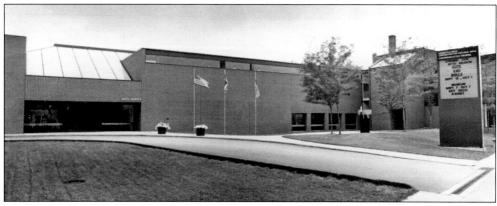

THE BECK CENTER FOR THE CULTURAL ARTS. The Beck Center, 17801 Detroit Avenue, named for wealthy Lakewood businessman and artist Kenneth Beck, opened October 25, 1976. The 500-seat theater cost $1.6 million, $600,000 of which was provided by Beck with matching funds raised by the Lakewood Little Theater adjoining the Beck Center. Art, dance, and acting lessons are taught and exhibit space provided for local talent. (CSU.)

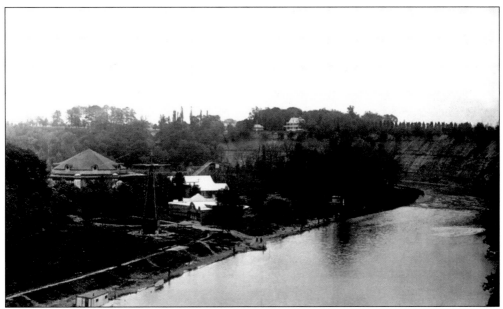

SCENIC PARK. Located at the west end of Lakewood, at the foot of Detroit Avenue along the banks of the Rocky River, was a small 90-acre amusement park called Scenic Park. In 1917 Lakewood purchased the recreation and picnic area for $43,000. Scenic Park has since become part of Cleveland Metroparks. (LHS.)

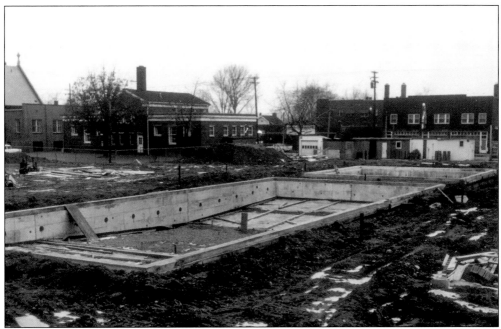

MADISON POOL CONSTRUCTION. Madison Pool is located in Madison Park, which occupies 15 acres on the southwest corner of Madison Avenue and Halstead Avenue. Here the pool foundation is being set for construction between 1955-1956. The City purchased the land in 1917 from businessmen Frederick Zimmerman and John Hahn for $40,222. Designed by architect John Lipaj, the pool cost $260,000 and included separate swimming and diving areas. (LHS.)

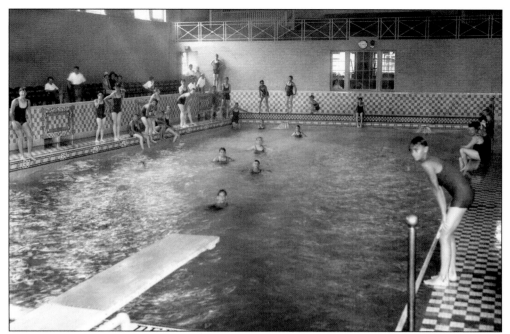

LAKEWOOD HIGH SCHOOL POOL OPENING DAY. In 1928 a swimming pool measuring 32 by 75 feet built at a cost of $120,000 was opened at Lakewood High School. Named in honor of Claude P. Briggs, a former high school principal, the pool provided residents like the boys pictured here with a place to swim and learn water safety. (CSU.)

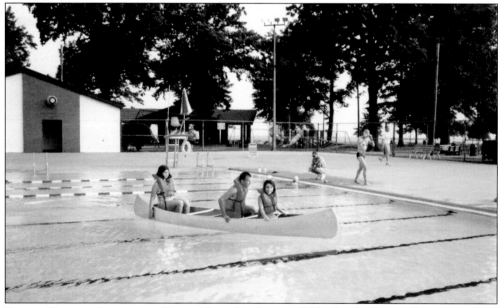

FOSTER POOL IN LAKEWOOD PARK. Named in honor of Charles A. Foster, Commissioner of the Lakewood Recreation Department from 1936-1967, this Olympic-size swimming pool was built in 1953 as the first of Lakewood's two outdoor municipal pools, the other being Madison Pool. In 1986 $1.1 million was spent to replace the pool house. Visitors can play and take swimming lessons or, as demonstrated here by three boaters, water safety classes. (CSU.)